Callander & Oban Railway

THROUGH TIME

Ewan Crawford

AMBERLEY PUBLISHING

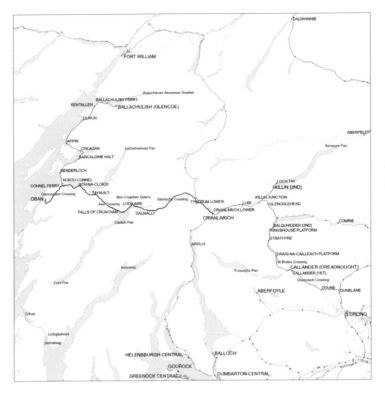

The Callander & Oban Railway, its Ballachulish Branch, the Killin Railway and the Dunblane, Doune & Callander Railway are shown in bold. Closed portions are shown in green. (Ewan Crawford)

For Beth and the many friends whose walk in the hills has involved a closed railway.

Front cover. Top: Killin Junction after closure in Easter 1966.
Front cover. Bottom: See page 96.
Back cover. Top: See page 94.
Back cover. Bottom: See page 20. All postcards are in the author's collection.

First published 2013

Amberley Publishing
The Hill, Stroud, Gloucestershire, GL5 4EP
www.amberley-books.com

Copyright © Ewan Crawford, 2013

The right of Author name(s) to be identified as the Author of this work has been asserted in accordance with the Copyrights, Designs and Patents Act 1988.

ISBN 978 1 4456 1405 2 (print)
ISBN 978 1 4456 1419 9 (ebook)

British Library Cataloguing in Publication Data.
A catalogue record for this book is available from the British Library.

Typesetting by Amberley Publishing.
Printed in Great Britain.

Introduction

The Callander & Oban Railway was, and is, an important part of the infrastructure of the west coast of Scotland. This line ran from Callander to Oban with a later branch to Ballachulish. Also included in this book are the Dunblane, Doune & Callander Railway and Killin Railway.

The main line ran west from central Scotland, crossing high, remote and sparsely populated areas to terminate by the sea on the west coast. This was a particularly difficult line to build and work. The scenic terrain traversed resulted in railways with steep gradients and tight corners and necessitated the construction of a number of large bridges. In summer, long and heavy trains were required to carry tourists to the west coast. In winter, passenger numbers dwindled and heavy snowfall could make the line difficult to work.

Today, only Oban to Crianlarich remains open as part of the West Highland Lines, with well used passenger trains meeting Caledonian MacBrayne's ferries at the Oban station pier and running south to Glasgow. Even the closed portions now serve the tourist: National Cycle Route 7 (the Rob Roy Way) uses parts of the system from Callander to Killin and National Cycle Route 78 uses much of the closed Ballachulish branch. A number of closed stations are now caravan sites or hotels.

At its height, interconnecting services ran to an extraordinary number of locations, opening up a huge area of the west as tourism developed. From Callander, coaches ran west into the Trossachs, connecting with steamers on Loch Katrine. Coaches, and later trains, ran east from Lochearnhead to St Fillans, Comrie and Crieff. From Loch Tay station pier, steamers plied to Kenmore for Aberfeldy. Coaches ran from Crianlarich south to Loch Lomond, from Tyndrum north to Ballachulish and Fort William, and from Dalmally south to Inveraray. Small steamers operated from Loch Awe station pier to Cladich and Ford (for Kilmartin, Lochgilphead and Ardrishaig), and from Ach-na-Cloich pier up Loch Etive, connecting with coaches to Glencoe. Steamers for Fort William called at Kentallen.

Oban's piers serve myriad destinations, routes varying over the years, including Glasgow (via the Crinan Canal), Fort William, Inverness (via the Caledonian Canal), Mull, Coll, Tiree, Jura, Islay, Lismore, Rhum, Skye, Kyle of Lochalsh, Arisaig, Barra, South Uist, Harris and Lewis.

The railway also carried freight: lead from Tyndrum, granite from Ben Cruachan, slate from Ballachulish, bauxite to Ballachulish (for Kinlochleven aluminium smelter), fish from Oban pier, foodstuffs for Oban and the Isles, oil for Oban and Connel Ferry and timber from Oban, Taynuilt and Crianlarich.

History of the Lines

Whereas ports such as Kyle and Mallaig developed around railway termini, Oban was already established and local businessmen wanted a railway. Oban was a call on the steamer route from Glasgow to Inverness (from 1812). A network of coach routes ran inland, both local and long distance. There was a thriving cattle market (dating from the sixteenth century), a fishing station (1780s) and a distillery (1794).

A number of high profile travellers – Pennant (1769), Boswell and Johnson (1773), Coleridge and the Wordsworths (1803), Scott (1810s) and Queen Victoria (1847) – were to document their journeys in an area unfamiliar to many of the British. The area was described in adventurous and romantic terms which encouraged tourism. The old drove route to the Falkirk Tryst gave the town a leaning to the east, but the rising industrial powers of Glasgow and Dumbarton had their drove routes too.

First proposals for a line from Oban to the Lowlands via Crianlarich came as early as 1845. The cruciform-shaped Scottish Grand Junction Railway (SGJR), backed by the Marquis of Breadalbane whose land it would cross, was to run to Callander. The Caledonian Northern Direct Railway (CNDR) was to run via Loch Lomond. Neither line attracted sufficient investment and both were abandoned.

The 1856 Act of the Dunblane, Doune & Callander Railway (DD&CR) authorised the construction of 11 miles of railway between Dunblane and Callander, which opened on 1 July 1858 with five trains a day in summer and two in winter. The Callander station, at the east end of the town, was a railhead for tourist traffic to the Trossachs. It was a single track line, with stations at Callander and Doune, which started at the north end of Dunblane station on the Scottish Central Railway (SCR).

In 1864 a railway from Oban was again proposed. The route from Oban to Crianlarich was agreed, but beyond this the course of either the unsuccessful SGJR or CNDR could be followed. Requests for support were sent to nearby lines – SCR, Forth & Clyde Junction Railway (F&CJR), Blane Valley Railway (BVR) – and also to powerful companies – Caledonian Railway (CR), Edinburgh & Glasgow Railway (E&GR), North British Railway (NBR). All responded favourably. The SCR offered £200,000 and the F&CJR and BVR offered, jointly, £70,000. The SCR chairman recommended support to the shareholders – this new line would give the company a coast-to-coast railway as the SCR had taken control of the Dundee & Perth Railway the previous year.

The Callander & Oban Railway (C&OR) accepted the SCR's offer. On 8 July 1865, the act was approved authorising a 70 mile railway from Callander (Callander and Oban Junction) to Oban, with a tramway to a pier in Oban. Total share capital was to be £600,000. The SCR would operate the line and would appoint five of the nine directors.

Within a month, on 31 July 1865, the DD&CR was bought by the SCR. The very next day the SCR was absorbed by the CR. Around the same time, another route to the west coast, the Dingwall & Skye Railway (D&SR), was authorised from near Inverness to the west coast. This company's share value was just over half that of the C&OR, perhaps a measure of the slightly easier ground to be crossed.

1865 also saw the appointment of John Anderson as secretary to the C&OR. He had risen from boy clerk to assistant to the general manager of the E&GR and had moved on, having opposed

its recent merging into the NBR. A passionate proponent of the C&OR, John Anderson dedicated his life to the completion and running of the line. The CR, on the other hand, had inherited an unwelcome commitment to a remote railway with doubtful commercial prospects.

In August 1870, the D&SR opened its 53 mile railway to a pier on the west coast at Stromeferry. The C&OR had opened only 17½ miles of the 70 mile railway authorised 5 years earlier, from Callander to a remote terminus in the hills, and the line was to take another 10 years to reach Oban. What went wrong?

The first sod was cut on 29 October 1866. As construction began, the only capital was from the CR (the £200,000 of shares that the SCR had committed). John Anderson put considerable effort into selling further shares, writing countless letters and travelling extensively around the west coast communities. The CR's shares were purchased in a series of payments, allowing the contractor to be paid. In the winter of 1867, as the contractor started work in the mountainous terrain of Glen Ogle, the company ran out of money. The contractor was obliged to accept an immediate small payment with the promise of a larger payment, with interest, when possible.

The indefatigable John Anderson continued to sell shares and pursue defaulting shareholders. To supplement income between 1868 and 1870 (before official opening) coal was brought by the contractor's engine to Lochearnhead (later renamed Balquhidder) and timber was taken back by return.

Concerned by finances and having control of the C&OR board, the CR was able to seek Parliamentary approval to abandon works west of Tyndrum, which was granted in May 1870. The CR authorised the works as far as Tyndrum. This would take the line beyond Crianlarich and the route to Glasgow via Glen Falloch, hopefully discouraging any proposals for a line to Oban by that route.

In preparation for the line's opening, Anderson arranged onwards coach travel to Killin, Aberfeldy, Oban and Ballachulish from the remote 'Killin' terminus at Glenoglehead. The coach would be needed – the town of Killin was 600 feet below and over three miles away. Anderson made the best of the remote location. In the press, the line was advertised as terminating in the 'Khyber Pass of Scotland'. Even hillwalking guides were to be available at the terminus.

Opening from Callander to Killin was on 1 June 1870. The former Callander terminus became a goods yard and trains swapped to the new Callander (Dreadnought) station. There were three trains per day, excluding excursions, taking 1 to 1½ hours in each direction.

Callander and Killin had wooden station buildings, whereas Strathyre and Lochearnhead had only booking offices. Callander was the only station with two platforms and Strathyre and Killin had loops. In 1871 a halt was opened at Kingshouse, funded by the nearby hotel. A turntable and wooden locomotive shed were provided at Killin. As early as the first year of operation there were several rockfalls in Glen Ogle, a continuing problem throughout the line's history.

In anticipation of the extension to Tyndrum, Anderson encouraged local hotels to promote excursions. There were to be coaches to Arrochar and Ardlui from Crianlarich and to Ardrishaig and Dalmally from Tyndrum. The Killin shed and turntable were moved to Tyndrum.

The extension opened in August 1873, with two trains a day taking two hours. Tyndrum was a mixed blessing as a terminus. The roads north to Ballachulish and Fort William and west to Dalmally, Oban and Inveraray had been improved but there was little at Tyndrum itself, just a

lead mining community. A tramway ran to the mines from the terminus. Mining activity was irregular and not a reliable source of income for the railway. Droving, stifled by the steamers, was revived by the new railheads. Luib, Crianlarich and Tyndrum stations were built in timber to a design similar to that at Killin. There were loops at each station. The locomotive shed was rebuilt in stone. Narrow gauge extensions were considered but not built.

Despite opening to Tyndrum, the continued threat of an alternative route to Oban via Loch Lomond spurred the company on to complete the line to Oban and a further act was passed on 11 July 1874. The CR and London & North Western Railway (L&NWR) were both to help fund the extension to Oban, the next portion of which was to Dalmally.

The extension started from a point east of the Tyndrum terminus (which became a goods yard) and ran via a new two-platform Tyndrum station to Dalmally, opening to goods on 1 April 1877 and to passengers on 1 May 1877. Dalmally was the junction of roads to Oban and Inveraray, to which coaches ran. Owing to an improved timetable, trains from Callander to Dalmally took 2 hours. Dalmally was provided with a stone shed. This station was used by the Duke of Argyll, being the closest to Inveraray Castle.

The next extension was to Oban. Construction alongside Loch Awe in the Pass of Brander was particularly difficult, as the hillside is steep. Indeed, the road is partly on a viaduct as a result. Concrete was used to build up the ledge on which the railway runs. Further west, the coastal route via Dunollie and Dunstaffnage was blocked by landowners and the prospect of a railway and tramway through Oban led to local opposition. As a result, the line was to run via Glencruitten and take an approach which turns through 180 degrees before terminating on a new pier. The total construction cost of the C&OR was £645,000.

Oban opened to goods on 12 June 1880. The ceremonial opening on 30 June was a grand affair and the day was declared a public holiday in Oban and Fort William. Steamers took part: *Iona* (tours round the islands of Kerrera and Lismore), *Chevalier* (coming south with passengers from Fort William) and *Lily* (with representatives of the L&NWR from Holyhead). A double headed special from Edinburgh and Glasgow arrived at the station. A banquet with speeches was held in the trainshed with dinner prepared by staff from Glasgow's St Enoch Hotel (the chief hotel owned by a CR rival!).

On 3 July 1880 *The Illustrated London News* enthused: 'Oban, the terminus of the line, is a delightful seaside watering-place. It is sheltered by the island of Mull from all harsh-blowing breezes. Being made so much more easily accessible by the railway, it will become a still more popular haven for holiday-makers. The railway station occupies a conspicuous and advantageous site close to the bay at the southern extremity of the village.' The article continues: 'The formation of the line through [the Pass of Brander] is a marvellous feat of modern engineering skill.' To tempt the tourist, the article included a number of illustrations. They were right; tourist numbers were high from the start. There were twenty coach trains to Oban during the Glasgow Fair. MacBrayne's piers had to be rebuilt due to increased traffic. The lucrative Lochaber mail contract was transferred to the railway from the steamers.

Anderson competed successfully with the D&SR for fish traffic, despite the longer sailing distance to the northern fishing grounds. A traffic sharing agreement was reached and the D&SR, which had become uneconomic, merged with the Highland Railway.

At opening, the journey from Callander took 3 hours. Loch Awe, Taynuilt and Connel Ferry had loops and two platforms. Oban station initially had three platforms, two of these serving one track, partly under a glazed trainshed. The frontage of the station faced the Oban Promenade. This fine station was described by Biddle and Nock as, 'A wooden-framed trainshed with timber cladding and a transverse ridged glazed roof. The offices are grouped around an attractive glass-roofed concourse, and the exterior has exposed timber framing with rendering and exposed gable framework in the form of brackets, like a Swiss chalet. The wooden clock tower with its steep-pointed top is a prominent landmark.'

The Oban goods yard and two road timber shed were at Lochavullin in the south of the town. A market was developed next to the yard. Goods sidings, with a crane and sheds, were located on the south part of the pier. A further station and pier opened at Ach-na-Cloich in 1881.

On 17 August 1881, an Oban to Dalmally train struck a fallen boulder at the Falls of Cruachan. Anderson asked the CR for assistance. A special wire fence was built alongside and above the railway. Should a falling boulder break the fence, semaphore signals would indicate danger, warning an approaching driver to proceed with caution. This system was dubbed 'Anderson's Piano' (due to the sound produced in a strong wind) and remains in use to this day.

In 1882, Callander station was considerably re-built, with a larger timber building and other facilities. At Glenlochy, a crossing was opened on the long rise from Dalmally to Tyndrum. That same year, George Brittain's Oban Bogies were introduced. These 4-4-0s with a short four-wheel tender were a great success for over 20 years, hauling goods and passenger trains. These were designed with the tight curves, severe gradients and 'weak' bowstring bridges of the line in mind.

A lengthy private siding was laid from a point east of Loch Awe station to Ben Cruachan granite quarry in 1885, terminating with zigzags. Traffic was worked by the quarry company to Loch Awe station.

A far more substantial branch was opened by the Killin Railway (KR). The Marquis of Breadalbane had hoped the C&OR would serve Killin, but his suggestion of a branch from Luib was rejected due to its long length without stations. He backed an independent 5 mile line at 1:70 to a new interchange station.

The ceremonial opening was on 13 March 1886. An inaugural train was met at the Loch Tay pier for a tour by a steamer which had come from Kenmore, with the party returning to Killin for a meal and speeches.

The line opened to the public on 1 April 1886. Killin station on the C&OR was renamed Glenoglehead. Breadalbane arranged vessels on Loch Tay ran in conjunction with the line. The C&OR did not allow public access to Killin Junction station, regarding it as an exchange location, and the station did not have a ticket office. Killin Junction was a substantial station, having a loop and two platforms on the main line, one an island, the other face of which had a loop and carriage sidings for the branch. At Killin, the station had a short platform and no loop. At the Loch Tay terminus, there was a platform, loop, locomotive shed and looped siding running to the pier. Signal boxes were provided at each section, there being two at Killin Junction.

The KR considered a loop at Killin and allowed rubbish dumping at the station by the local authority, hoping that this would raise the ground level. However, the loop was never laid and passengers did not relish the smell!

Up to eight services ran per day. The travel time from Loch Tay to Killin was around 5 minutes. From Killin to Killin Junction took around 20 minutes, the return journey taking 15 minutes. Locomotives used were two CR Killin Pugs which were 0-4-2STs, replaced by 0-4-4Ts in 1889 (both Drummond engines).

The West Highland Railway (WHR) was opened in 1894. (See John McGregor's *The West Highland Line*, also by Amberley.) The C&OR had strenuously opposed this railway, making unsuccessful counterproposals for lines in Glen Falloch and from Connel Ferry to Fort William via Ballachulish. There was a brief boom in traffic during construction; the goods yard at Tyndrum was used as a depot for the contractor and the branch to Ben Cruachan carried stone for bridge building and ballast.

The WHR crossed over the C&OR at Crianlarich. A link was built at the WHR's expense between the north end of the WHR's Crianlarich station and a point west of the C&OR's Crianlarich station. On the C&OR a loop and interchange sidings were installed. Due to disagreements, exchange of traffic did not begin until 20 December 1897.

With rising traffic, further capacity was needed. Further passing loops had been provided at St Brides (1893), Awe Crossing (1893) and Glencruitten (1900). In 1901, the Dunblane to Doune section was doubled and the loop at Drumvaich opened. Doune was rebuilt with a large island platform and glass canopies. In 1902, Callander (Dreadnought) to Callander and Oban Junction was doubled.

In 1902, the second 'Oban Bogies' 55 class 4-6-0s were introduced by McIntosh. These were to be used on the line for the next 30 years.

The 27 mile Ballachulish branch was opened on 24 August 1903. The origins of the branch were more political than practical. At this time, the WHR was being extended to Mallaig with government funding. If the C&OR could reach Fort William, it might have access to this extension. Further, the WHR had promoted a railway to Ballachulish, uncomfortably close to Oban. Ultimately, the two lines agreed to promote to, but not meet at, Ballachulish. The WHR did not build its branch, but the C&OR did. This line ran largely by the sea and through easy terrain and was not a difficult construction, except for the large bridges built by William Arrol at Connel Ferry and Creagan. The line terminated at the Laroch slate quarries, close by Ballachulish. Although a triangular junction was planned for Connel Ferry, only the east to north curve was ever used.

Connel Ferry station was rebuilt and enlarged. The westbound platform became an island and bays were added, the layout requiring a signal gantry at the west end. Stations were opened at Benderloch, Creagan, Appin, Duror, Kentallen, Ballachulish Ferry and Ballachulish. Most stations had two platforms with a standard design of two storey building. Creagan resembled a WHR station. Ballachulish Ferry had one platform and a minimal building. Ballachulish had two platforms and a single storey building at the buffer end. A generous goods yard was laid out at Ballachulish where there was interchange with the existing slate quarry tramway. Between four and seven trains ran per day, some from Connel Ferry, others from Oban (requiring a reversal at Connel Ferry). A two road locomotive shed was opened at Ballachulish.

Oban station and pier were expanded in 1904, with the addition of two further platforms on the sea side of the station outside the trainshed, a new signal box and further carriage sidings

on the pier. In 1905, the line from Comrie reached the C&OR. Lochearnhead station, renamed Balquhidder, was re-sited slightly further south with two platforms on the C&OR and one with a loop for the branch. The shed was to prove useful to the C&OR for stabling a pilot engine for Glen Ogle. With the system now at its height, John Anderson retired in 1907 after more than forty years with the C&OR.

During the First World War, a siding was laid at Ach-na-Cloich for timber, and a number of sidings on the Ballachulish line were lifted for use in France, as was the Ben Cruachan quarry branch. The third 'Oban Bogies', designed by William Pickersgill, were introduced in 1922. In 1923, as part of the post-war restructuring of the railways in Britain, the C&OR, KR and CR were grouped into the new London, Midland & Scottish Railway (LMS). The spur between the WHR and C&OR at Crianlarich was first used by a passenger train on 10 June 1931. Stanier Black 5s were introduced in 1938.

Following the outbreak of the Second World War, Loch Tay station was closed to passengers and gravity shunting was used for passenger trains terminating at Killin. Achaleven yard was laid in at Connel Ferry in connection with a new airfield at North Connel and a naval repair base at Dunstaffnage. Further sidings were laid in the Pass of Brander and at St Brides to the west of the loop.

After the war, the LMS was nationalised as part of British Railways (BR). After 23 May 1949, passenger trains started to use the Crianlarich spur more regularly. Excursions continued and often travelled long distances from locations such as London St Pancras, Birmingham or Bristol and whether the trains came by Glen Ogle or Glen Falloch was irrelevant. On the Killin branch, 2-6-4Ts were introduced. Heavier than their predecessors, this necessitated re-laying of the line.

In 1961, NBL diesel Bo-Bo Type 2 locomotive pairs were introduced, the early change to diesel due to the expense of taking coal to Oban. Local services to Callander now often used Diesel Multiple Units. In 1963, the introduction of BRCW Bo-Bo Type 2s led to the end of steam on the line. Oban shed closed, although the turntable remained for some time. Also that year, another rockfall in Glen Ogle required construction of a retaining wall.

The Reshaping of Britain's Railways was published in 1963. Complete closure of the line between Dunblane and Crianlarich, along with both the Killin and Ballachulish branches, was planned: 71 miles of a 113 mile system. Crianlarich to Oban was to be retained. Freight was withdrawn between Dunblane and Crianlarich in 1965, now running via Loch Lomond. The Ballachulish branch had carried upwards of twenty containers of bauxite a day. This now travelled by road from Fort William to Kinlochleven. For now, the evening train from Oban retained its restaurant car and sleeper coach for London.

Closure of Dunblane (Springbank Mill) to Crianlarich Lower was planned for 1 November 1965. In Killin, 500 people signed a petition calling for retention of the lines.

The rockfall of 27 September 1965 in Glen Ogle blocked the line not far south of the viaduct. Repairs were expected to take a month and with only five weeks remaining before the planned closure, an early closure was announced. The Killin train ran through to Crianlarich to connect with the West Highland Line, the service ending on 28 September.

From 4 October, the Oban service ran from Glasgow Queen Street. The sleeping car for London ceased. Callander continued as a terminus until 1 November. Glasgow to Oban was now

quicker and there was an increase in train frequency south of Crianlarich, some compensation for the loss of the local Craigendoran to Ardlui service the year before.

It is said that the lifted track of the Callander and Oban found its way to Mexico for the Mexico City Metro, although given the short lengths a line is cut into during lifting, this should be treated with caution.

Crianlarich Lower was retained as a timber loading yard. However, the Ballachulish branch closed on 26 March 1966. Loops were taken out at Glenlochy Crossing, Loch Awe and Awe Crossing that year, Crianlarich Junction and Connel Ferry in 1967 and Tyndrum in 1969. During the 1970s, Class 27s and 25s dominated the West Highland Lines as the new arrangements became established. In the mid-1970s trains arriving at Oban could only access Lochavullin and platform 1 (now a goods siding) by means of two reversals. The carriage siding by platform 1 was relocated. An oil siding was laid at the former location of the turntable at Lochavullin; the rest of that yard was removed.

Class 37s became regularly used during 1981. 1982 saw the closure of Oban signal box and rationalisation of the trackwork with platforms 1 and 2 lifted. Only platform 3 remained available to passenger trains. Platform 4 became a locomotive release line. The curve leaving the remaining platforms is not as severe, allowing a faster departure from the station. The oil depot siding was now accessed by a ground frame at the former goods junction.

Around 1983, three Class 25s were modified into mobile Electric Train Heating generators (ETHELs). Glasgow's Eastfield depot chose a Highland terrier logo for the side of its locomotives. The Friends of the West Highland Lines was formed that year, to promote development of West Highland train services.

Around 1985, the Royal Scotsman, a luxury train, began touring Scotland during the summer months. This train has visited Oban although the itinerary varies. 37/4 locomotives displaced the other 37s and ETHELs. Loch Awe station was re-opened. The new station at Oban was officially opened on 3 January 1986. Taynuilt and Dalmally signal boxes closed when train operated points were installed. In 1987, the direction of the loop at Taynuilt was reversed, allowing easier access to the sidings and Oban's trainshed was demolished. Radio Electronic Token Block (RETB) came into use on 27 March 1988. There were some issues with radio reception; I recall a signalman thoroughly enjoying being a 'token' on the West Highland Lines when there were problems – only if he was on board was the train allowed to proceed! Falls of Cruachan station re-opened and nearby the 'Tea Train' carriage, where meals were served, was placed next to Loch Awe station by slewing and replacing the track.

Another major change took place on 23 January 1989, when the Class 156 Sprinters were introduced. Since then, in winter, a joined pair of Sprinters runs north from Glasgow, splitting at Crianlarich, with the front portion continuing to Oban and the rear to Fort William and Mallaig. In summer, some of these run north separately, increasing the frequency south of Crianlarich. Typically, there are three trains a day and more in the summer. Oban's platform 4 came back into use for passenger trains and the sidings were remodelled as the pier was re-developed.

Taynuilt station building became a brewery and pub in 1990 and the signalbox was re-located. Oil travelled to Oban pier regularly and timber was loaded at Oban, Taynuilt and Crianlarich Lower. Crianlarich Lower was lifted around 1993, when remaining timber traffic was swapped

to the upper station. The approach has been cut back to the site of the former Crianlarich Junction (East) box. Sadly, one of the last remaining timber station buildings between Callander and Oban, that at Taynuilt, met the same fate as many other C&OR station buildings and was destroyed by fire around 1994. Fortunately, the C&OR crest above the entrance was preserved and is now displayed in Caledonian MacBrayne's new Oban terminal.

Dalmally's canopy was re-glazed in the early 2000s and timber traffic continued somewhat fitfully, ceasing at the end of the decade. In 2002, the Rob Roy Way was developed using some of the former trackbed between Callander and Killin, and the Glen Ogle viaduct was repaired.

On the evening of 6 June 2010, the Glasgow to Oban Sprinter derailed in the Pass of Brander just west of Falls of Cruachan when the train struck fallen boulders. The leading coach was left overhanging a substantial drop with only trees and the coupling to the rear coach holding it in place. Removal of the carriage was difficult, requiring a large mobile crane on the parallel road. Both road and railway were closed and the carriage was recovered on the 11th, the line re-opening on the 14th. The Rail Accident Investigation Branch highlighted the growth of vegetation in the area. Regrettably, the boulder was located on the track side of Anderson's Piano. Although visible boulders on this side are wired to the system, the landscape inevitably alters with time. Vegetation removal and evaluation of the slope were recommended.

From May 2014, the number of trains to and from Oban will double from three to six trains a day between Monday and Saturday, with a northbound service arriving before 9 a.m. and an evening service connecting with the sleeper at Crianlarich, effectively re-instating a service lost in 1965.

Exploring the line by car
The following locations are worth visiting on a car journey from east to west:

• Callander – the former station site is now the Station Road car park, behind the Dreadnought Hotel. A length of platform remains at the west end of the site (page 26). At the east end, Ancaster Road crosses the former line on an overbridge (recently infilled), affording a good overview.
Railway era fencing remains and the bridge manufacturer's plates are still in place (page 25).

• Balquhidder – the station was not at Balquhidder but north of Kingshouse Hotel on the A84. The station steps and entrance tunnel remain and are visible on the right (page 32). The station itself has been obliterated.

• Glen Ogle Viaduct – south of the viaduct, the hillside above the railway is covered in boulders. A rockfall here closed the line prematurely. The viaduct is visible on the left as the A85 climbs Glen Ogle.

• Glenoglehead – this is the site of the original 'Killin' terminus. There is a small dirt car park on the left at Lochan Lairig Cheile. A five minute walk north along the (sometimes muddy) closed railway will take you to the station remains: platforms and two privately owned railway houses. The dip in the east platform was for the tablet catcher (page 38).

• Killin – little remains of the station at the end of the Lyon Road in Killin (page 46). A girder bridge still spans the River Lochay to the north and the Dochart Viaduct can be reached by a longer walk south along the former railway.

• Crianlarich Junction – there is no public parking here. A girder bridge crosses the junction site west of Crianlarich. Looking east, the line on the right is the spur to the West Highland and that on the left is the C&OR (page 53).

• Dalmally – the fine stone station building here still has its glass canopy and the redundant signal box still stands (page 59). The heron fountain is on the westbound platform.

• Loch Awe – both platforms are intact, with one in use today. The former steamer pier is adjacent to the station and the Loch Awe Hotel overlooks it. A camping coach (formerly the 'Tea Train') is located by the station.

• Pass of Brander – above the A85 to the right, the semaphore signals of Anderson's Piano can be seen at regular intervals near Falls of Cruachan station (see page 63). These are the only semaphores on the line today.

• Taynuilt – although the station building was destroyed by fire, the timber signal box still stands (page 66).

• Connel Ferry – the impressive Connel Ferry Bridge carries the A828, allowing the car driver to enjoy crossing the bridge once crossed by trains (page 71).

• Creagan – the A828 crosses Loch Creran via the modified Creagan Bridge. This can be viewed from the minor road below on the south bank (page 74). Further north, the restored station building and water tank at Creagan can be seen on the right above A828.

• Kentallen – the station building has been incorporated into a hotel and restaurant. Inside, many related documents are on display. The former platform side of the station building is indoors. Outside, platform portions remain. The pier still exists, but steamers no longer call (page 77). The water tank stands in the garden of a former railway house.

• Ballachulish – the building is now a health centre (page 80). Nearby, at the time of writing, the locomotive shed still stands unused (page 82).

On foot
A number of sections make a good walk or cycle:
(* denotes parking, sometimes private such as for a hotel)

• The Callander Trail visits the site of the later station and has detailed information boards.

• The Rob Roy Way follows the course of the railway from Callander to Killin. The semaphore signal at the start of the walk is not original. From Callander* the path can be walked or cycled (look out for three crossings of the Leny) to St Brides* and on to Strathyre* alongside Loch Lubnaig. From Strathyre to Kingshouse* the footpath follows a different route but the very determined railway walker can follow the original trackbed for much of this length. Beyond Kingshouse, the path and railway part company again and a determined walker can continue along the railway, after crossing the busy A84, although dropping down to the road is advisable at Leitters (close to the former Balquihidder station) due to houses. At Balquhidder*, the footpath follows a different route again before taking the former Comrie line trackbed past Edinchip. The railway's route, initially obliterated, can be pursued until the two merge around Craggan. The climb up to Glenoglehead is to be recommended. The view above Lochearnhead was recognised as the best view from a train in Britain (before the West Highland Railway opened) and the walk takes in the infamous rockfall before reaching the viaduct, followed by the remote former terminus at Glenoglehead*. Beyond, the Rob Roy Way takes a different and shorter route to Killin, but the railway can be followed to Killin Junction where some platforms and a derelict cottage remain. The route to Killin* can be walked. Take care crossing the busy A85 at Lix Toll. The two footpaths merge near Killin. The route is walkable to Loch Tay where there are now private houses.

• The Cruachan Quarry branch makes an interesting walk, although this is not an official footpath and parking is not provided. At the quarry end the zigzags can still be discerned in winter.

• Much of the Ballachulish branch trackbed is part of National Cycle Route 78. The views of the sea along this route, particularly at sunset, are stunning, notably at Castle Stalker near the former Appin station. It is generally a very level route. Former station sites can be visited at Benderloch*, Appin*, Kentallen* and Ballachulish Ferry.

By train
On an Oban bound train, sit on the left between Glasgow and Arrochar to enjoy views of the Clyde, Gare Loch and Loch Long, then switch to the right for Loch Lomond. At Crianlarich, do make sure you are in the carriage for Oban! Between Crianlarich and Tyndrum, the West Highland Railway runs parallel and to the right. At Dalmally, the Heron fountain can be seen on the platform to the left; immediately after, look right to see the station building with its glass canopy. After Dalmally, look to the left for views over Loch Awe and iconic views of Kilchurn Castle. At Falls of Cruachan the loch narrows in the Pass of Brander and the protective signals of Anderson's Piano are on the left. After Taynuilt, most of the best views are on the right. First comes a view of Loch Etive and the closed station at Ach-na-Cloich, followed by the imposing grey Connel Ferry Bridge spanning Loch Etive at the Falls of Lora. Glencruitten box can be seen on the right followed by the first glimpse of Oban as the train drops down to the harbour.

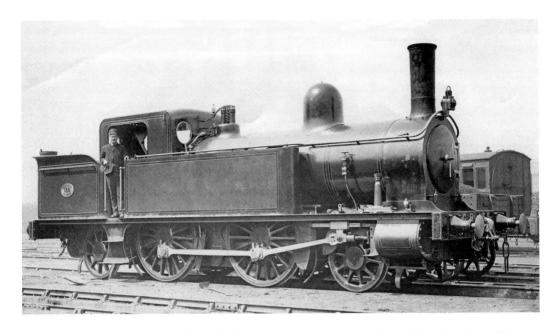

In these photographs we now follow the line west. We start at an unknown location where CR No. 155, an original Brittain 2-4-2T loco designed for the C&O route, is seen. Due to continual derailments these were withdrawn from the line being replaced by the first 'Oban Bogie' (see page 58). (The late Ian Peddie Collection, courtesy Donald Peddie)

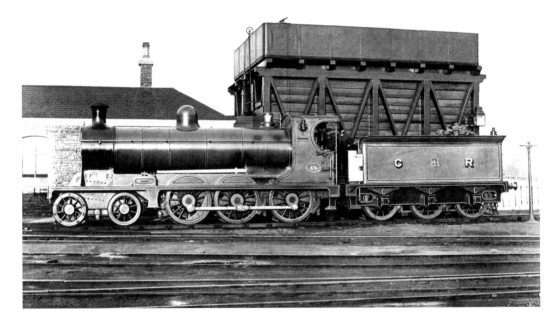

Stirling
CR No. 59, a McIntosh 55 Class 4-6-0, is seen at Stirling, Burghmuir shed (BR's Stirling South). This was the second type of Oban Bogie and is seen around 1910. This class lasted into the 1930s. This shed provided motive power for the C&OR and a snow plough fitted locomotive was kept in steam in the winter. (The late Ian Peddie Collection, courtesy Donald Peddie)

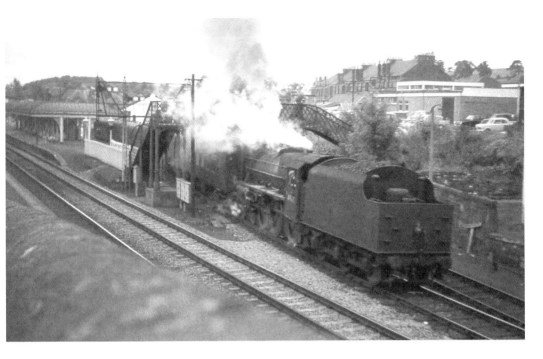

Dunblane
On 27 July 1965, 45168 leaves Dunblane's island platform with a train to Callander. (G. W. Robin)

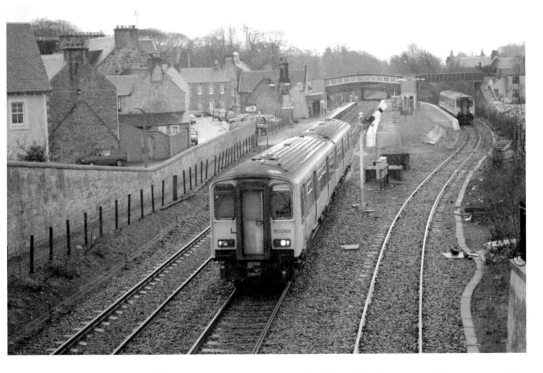

Two sprinters at Dunblane station in 1992. The island platform's curved face was used by Callander local trains. (Ewan Crawford)

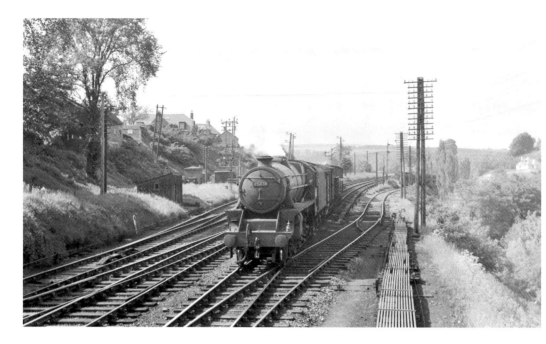

Black 5 No. 45474 coming south at Dunblane Junction with an Oban to Stirling goods working on 12 June 1954. In the siding on the right hand side is 4F 0-6-0 with a van train. The line to Callander had been single track but was doubled around 1902. The junction was altered so that trains for Oban could run from the island platform without fouling the mainline. (The Late Ian Peddie Collection, courtesy Donald Peddie)

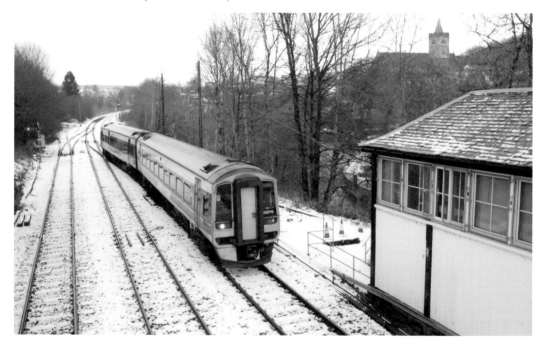

The branch, now lifted, remained in use for years as a siding for tampers. That siding is now reverting to nature. A local service is seen turning back in this 2008 view. (Ewan Crawford)

Doune

On 12 April 1963 CR123 took the Scottish Rambler No. 2 to Crianlarich via Callander, returning via the West Highland. Here's a fine view of the token exchange at the west end of Doune as the train heads for Callander. Other than the locomotive, now at the new Glasgow Transport Museum, the only other thing remaining in this view is the green shed in the distant left. (John Robin)

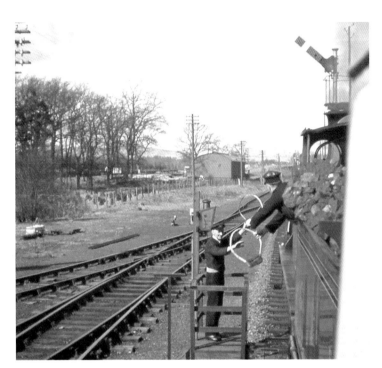

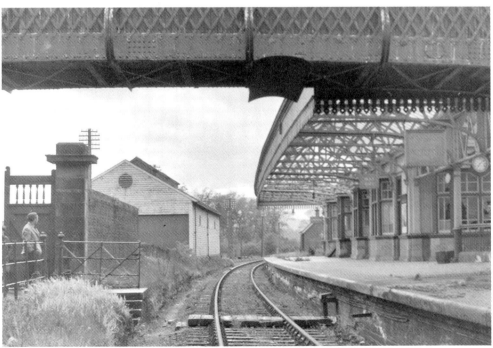

The station is more or less intact in May 1967, some 19 months after closure. This view looks west from the westbound face of the island platform at Doune. Although the building was demolished and track lifted, this location was to remain fairly intact until the 1980s. (Colin Miller)

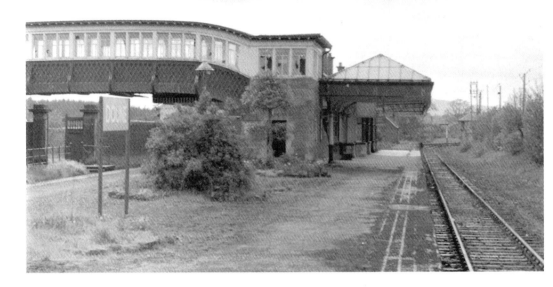

Doune station was rebuilt in fine form around 1901. The original station was a simpler two platform station. This is the view west, also in May 1967, from the former eastbound platform. The signal box can be seen in the distant right. (Colin Miller)

In the 1980s the large island platform remained intact and the goods shed still stood. This view looks west with Ben Ledi in the distance. John Robin's photograph (page 17) was taken from just beyond the goods shed seen here. (Ewan Crawford)

Most of the station site is obliterated, becoming a housing estate, with two exceptions. The stationmaster's house still stands by the entrance and this very short portion of the platform remains. This is the extreme eastern end of the station looking west. (Ewan Crawford)

Drumvaich Crossing
Drumvaich loop was opened in 1893 to increase capacity on the single track section between Callander and Doune. This view looks west over the site of the former crossing. The signal box was one of several combined house and signal box buildings on the line and still stands today. (Ewan Crawford)

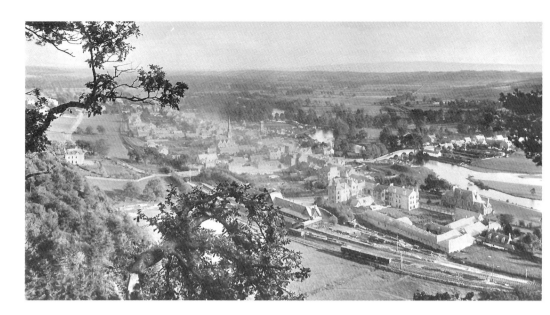

Callander

In this Caledonia Series postcard of Callander (Dreadnought) (pre-1902 as the line east is single), the words 'Railway coach and hiring stables, office, railway station' are painted on the roof of an adjacent building. Many adverts are on display in the station. To the right of the station is the seventeenth-century Dreadnought Hotel. Unfortunately it is not possible to take a 'now' photograph due to tree growth on the Callander Crags. (Caledonia Series)

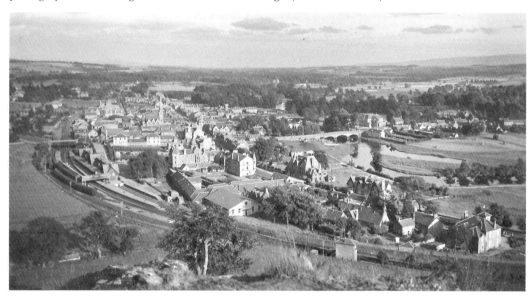

This Judges postcard shows Callander (Dreadnought) station from the Crags in its post-1908 condition (the track east to Callander and Oban Junction has been doubled and a scissors installed). Note the fine station footbridge with a clock. This was destroyed in 1947 when a freight train split in the Pass of Leny, the rear running to the station and striking a passenger train. There were no injuries. A white painted buffer on a carriage siding to the east of the station can be seen in the distance. (Judges Ltd)

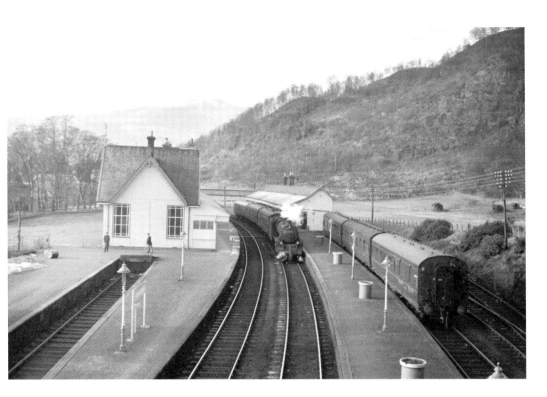

This was the view looking west over Callander (Dreadnought) station in mid-1965 with Black 5 No. 45423 about to leave with the 1.30 p.m. to Glasgow, Buchanan Street. The platforms are looking somewhat quiet. (The late Robin Barbour, courtesy Bruce McCartney)

This 1989 photograph also looks west over the station site. The site of the station is now a car park although something of the overall shape still exists on the ground. (Ewan Crawford)

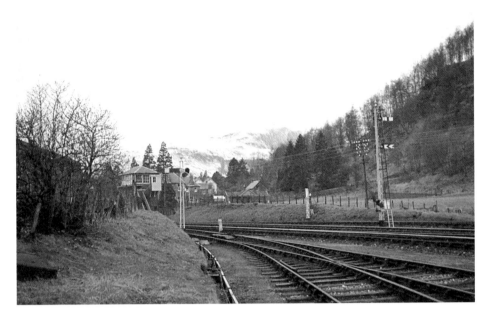

The view west at the west end of Callander station showing the west end signal box. The two lines closest to the camera were for the bays. (John Robin)

Callander station, looking west at the west end fifty years later. Something of the former appearance remains, the car park narrows in the distance. The tree growth on the crags can be seen. Quite a few houses have been built in what was a field. (Ewan Crawford)

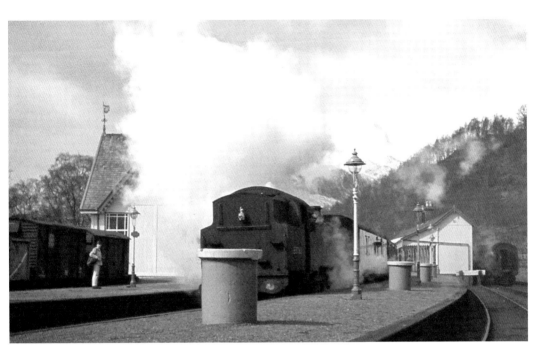

Standard Class 4 2-6-4T No. 80063 leaves Callander with a train for Stirling. (John Robin)

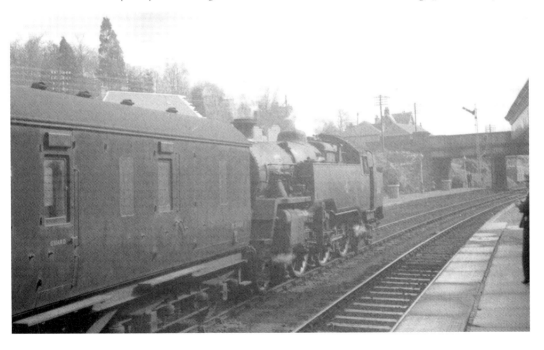

The same train is seen leaving in this view. John Robin can be seen standing on the trackbed below the bridge. Beyond the bridge Callander East signal box can be seen. The double track east to callander and Oban Junction was now two single lines, the former eastbound being the line to Doune, and westward uses to access the original callander station, then a goods yard. (The late R. Sillitto, courtesy A. Renfrew)

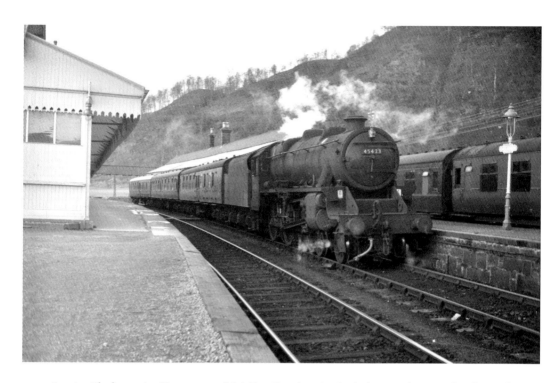

Stanier Black 5 4-6-0 No. 45423 of Stirling Burghmuir shed about to leave Callander and head for home on the first day of February 1964 with the 1.30 p.m. to Glasgow Buchanan Street. (The late Robin Barbour, courtesy Bruce McCartney)

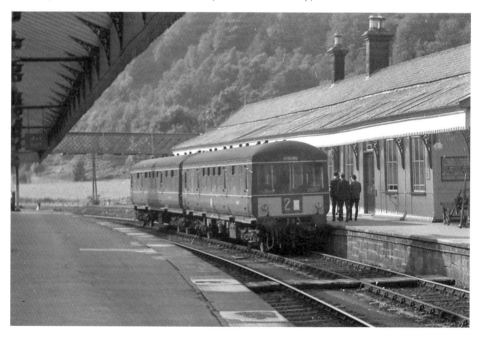

DMUs were used on local services before the line closed. Here a DMU prepares to leave Callander station in September 1965. The front panel shows Stirling. (Colin Miller)

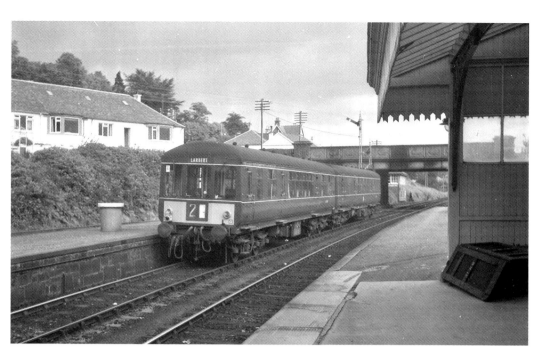

This is the rear of the same DMU leaving Callander. The rear destination panel says Larbert. This photograph was taken in September 1965, just before the rockfall. Callander was to survive the section west to Crianlarich, but not for long, closing on 1 November 1965. (Colin Miller)

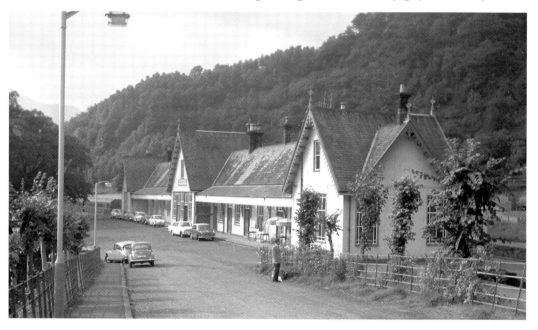

Looking down to the station from Ancaster Road. Coaches ran into the Trossachs from the station forecourt which later became popular for car parking. Of course, after the station was demolished this made the entire station area available for parking. There's not much happening at the station but there's stock in the northern bays and a tempting looking café. (Colin Miller)

This is the last remaining section of platform. It's the remains of one of the two bay platforms at the north end of the station. (Ewan Crawford)

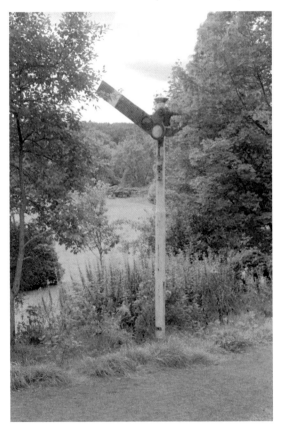

This signalpost stands at the start of the walk into the Pass of Leny and on to Strathyre. I'm afraid it's not original, but it is a nice touch. (Ewan Crawford)

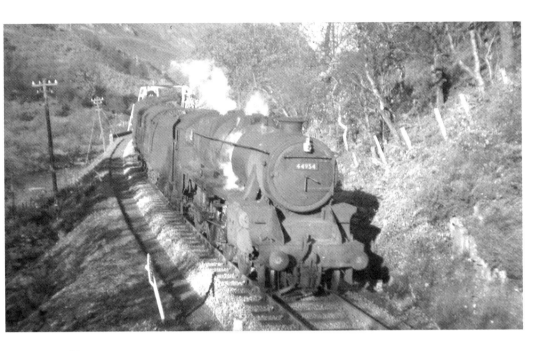

Pass of Leny
A Glasgow Buchanan Street to Oban train, hauled by Black 5 44954, climbs in the Pass of Leny in 1957. The train is crossing one of the 'weak' bridges which caused a headache for locomotive designers over the years. (The late Frank Spaven, courtesy David Spaven)

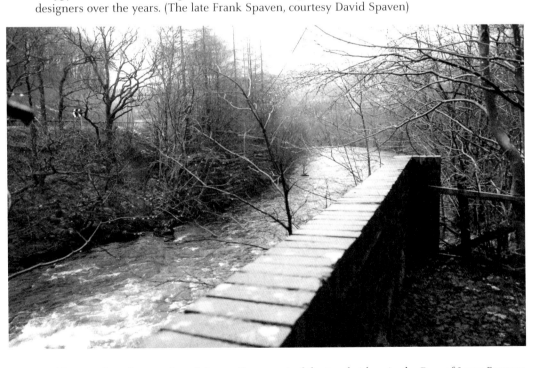

Looking south at the remains of the northernmost of the two bridges in the Pass of Leny. Because the two bridges have been removed the walkway does not entirely follow the former railway. Nearby are the dramatic Falls of Leny. (Ewan Crawford)

Craig-na-Cailleach

This is the view today from the remains of the Craig-na-Cailleach platform, looking to Strathyre. Little remains of the halt here but the surfaceman's cottage is now a private house called Rock Cottage. The halt was used once a week to take surfacemen's wives shopping. It's sad to see the trackbed like this today – it often won the 'Prize Length' award for being kept in immaculate condition. (Ewan Crawford)

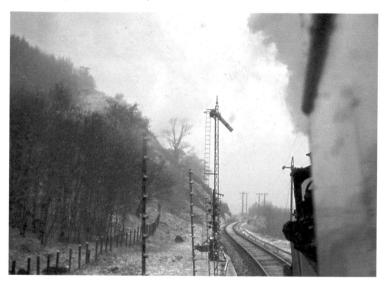

CR 123, heading north by Loch Lubnaig in 1963, meets snow near Craig-Na-Cailleach. Note the trip wire signals up ahead; these were similar to those in the Pass of Brander. (John Robin)

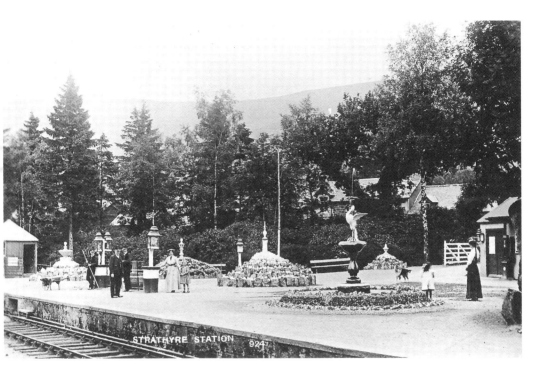

Strathyre

This postcard view shows the southbound platform at Strathyre with the heron fountain but without the main station building, which burned down in 1893. Strathyre was a passing loop and station from opening and a village was established as a result of the railway. (Valentine's Postcard)

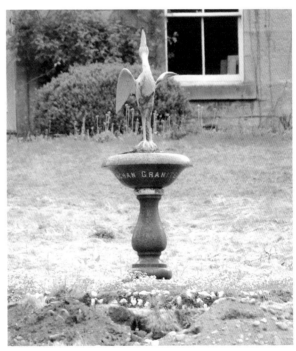

The heron survives and is now in the garden of a local house – it can be seen from the A84. This heron was cut from rock from the Ben Cruachan quarry, served by a private siding of the C&O. The heron was a prize for a long serving stationmaster under whose term the station regularly won best kept station award. (Ewan Crawford)

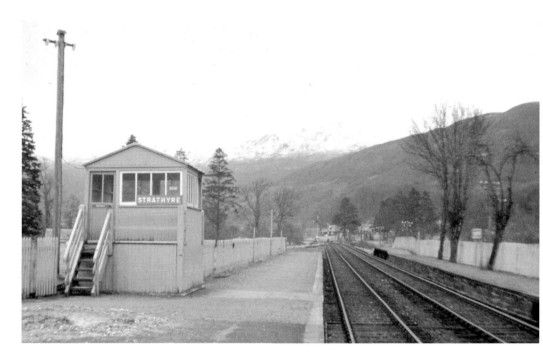

This photograph was taken after closure of the line. The view looks south and shows the crossing loop. Strathyre, in common with most of the stations on the Callander to Tyndrum section, had what might be described as a garden shed of a signal box. Track here was lifted in 1967. (The late Frank Spaven, courtesy David Spaven)

This view is quite a contrast to Frank Spaven's earlier view. The station site now has housing, however the Rob Roy Way picks its way round the back of the houses. (Ewan Crawford)

Balquhidder

Balquhidder East signal box on 6 July 1955 with Black 5 No. 44970 on the 9.18 a.m. Oban to Glasgow Buchanan St and Edinburgh Princes Street. The line to Comrie was closed by this date and a sleeper clamped across the track, but lifting had not yet taken place. (The late Ian Peddie, courtesy Donald Peddie)

The platform area is now landscaped. This 1990 view gives some idea what remains. The view is along the former northbound platform with the remains of a station sign, two bare poles, still in place. For Oban-bound trains Balquhidder was at the start of the long climb up to Glenoglehead. (Ewan Crawford)

The imposing frontage and entrance to Balquhidder station alongside the A84 looking north on 14 May 2008, showing the gated entrance to the former passenger subway. The site of the platforms is now the Balquhidder Braes holiday park (www.balquhiddrbraes.co.uk). (John Furnevel)

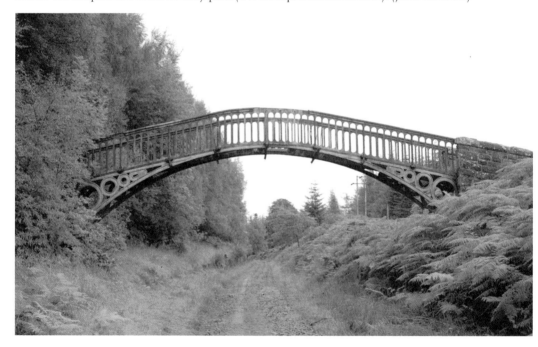

There was a tense relationship with the owner of the Edinchip estate, who did not wish the line to pass through his land. This resulted in the building of the most intricate overbridge to cross this line, seen here. (Ewan Crawford)

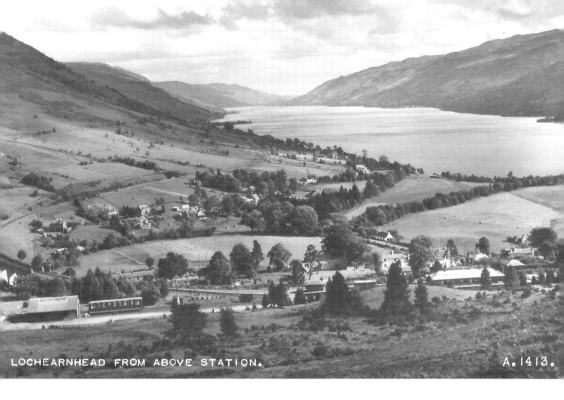

LOCHEARNHEAD FROM ABOVE STATION. A.1413.

Loch Earn
The view from train windows over Loch Earn was considered to be the finest view from a train anywhere in Britain. This is roughly the view that would have been had from the line and looks over both Loch Earn and Lochearnhead station on the line to Comrie. (Valentine's Postcard)

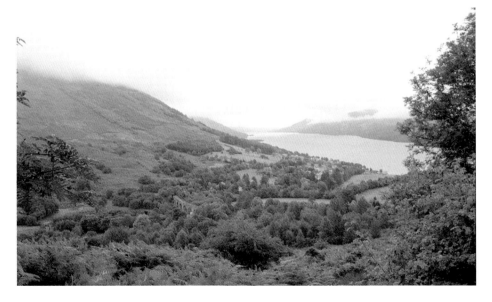

The same view can be appreciated from the footpath today. The viaduct on the Comrie line can be seen far below. This may have been considered the finest view, but after the opening of the West Highland Railway that must have come under review! (Ewan Crawford)

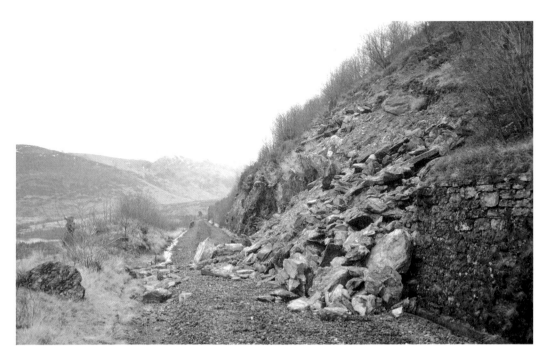

Glen Ogle
This is the landslip that prematurely closed the Callander to Crianlarich section on 27 September 1965. The photograph was taken in December 1966, not long after after the rails had been removed. (The late Frank Spaven, courtesy David Spaven)

A view of the same rockfall in 1993. In the many years since closure there has not been a substantial fall here but of course the rockfall was not the only reason for closure. This was a black spot for many years; the retaining wall to the right is testimony to this, last re-built in 1963. (Ewan Crawford)

Near the top of Glen Ogle, and above the viaduct, No. 45154 *The Lanarkshire Yeomanry* is seen on 6 July 1955. This was the 1.09 p.m. Stirling to Oban passenger working. This locomotive was one of the few named Black 5s. (The late Ian Peddie, courtesy Donald Peddie)

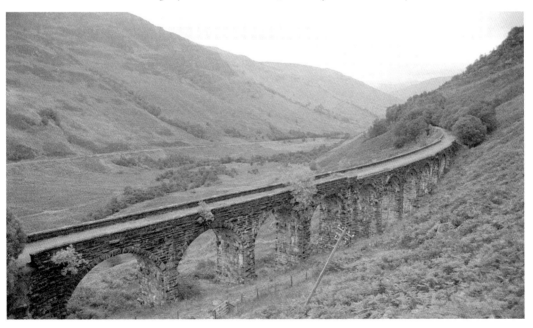

Glen Ogle Viaduct seen from above. This viaduct has been renovated in recent years after conversion to a footpath. Parapets have been added since the photograph was taken in 1993. Walking the trackbed is much easier now – even in the 1990s there was still a fair amount of ballast on the trackbed. (Ewan Crawford)

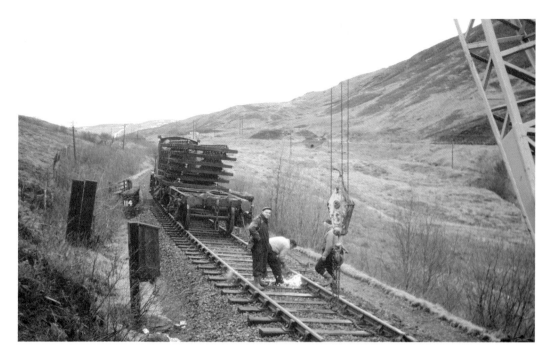

This was, of course, quite literally the last train on the line. The December 1966 view shows the track being cut into short panels. (The late Frank Spaven, courtesy David Spaven)

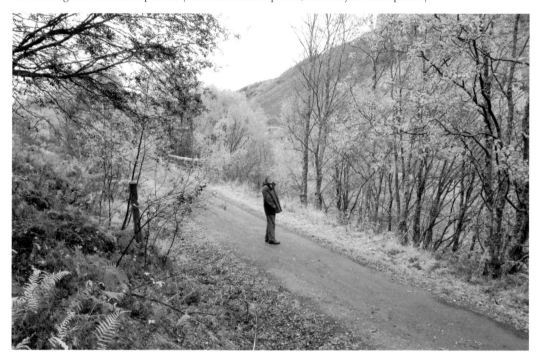

A walker pauses at the very location where a ganger paused during the dismantling of the railway in the 1960s. After the sad sight of the previous photograph it is good to see the trackbed in use again, albeit for other purposes. (Ewan Crawford)

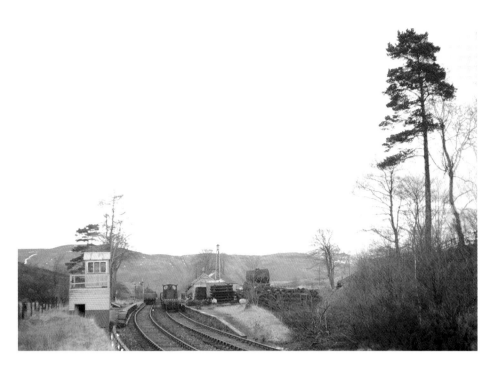

Glenoglehead

Glenoglehead Crossing seen from the south end during track-lifting in December 1966. This remote spot was the terminus of the line, as first opened in 1870, and even after extension west remained the station for Killin from 1870 until the Killin Railway opened in 1886. The loop, with its somewhat garden shed like signal box, remained open until the end. (The late Frank Spaven, courtesy David Spaven)

Winter always helps when visiting a closed station site – tree growth hides much of what still exists. This photograph was taken to match Frank Spaven's view. Nothing remains of the signal box today but the platforms really add poignancy to this location. (Ewan Crawford)

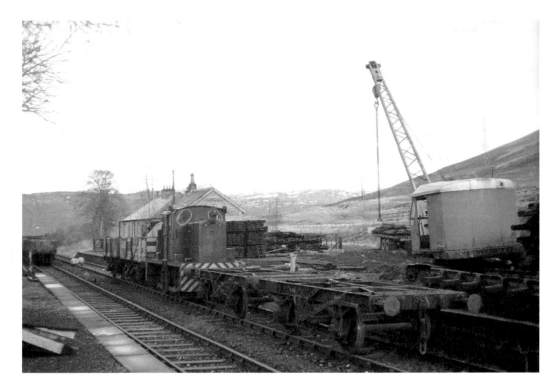

Glenoglehead was one of the bases for the contractor who lifted the line. Here removed panels are being lifted onto the platform in December 1966. (The late Frank Spaven, courtesy David Spaven)

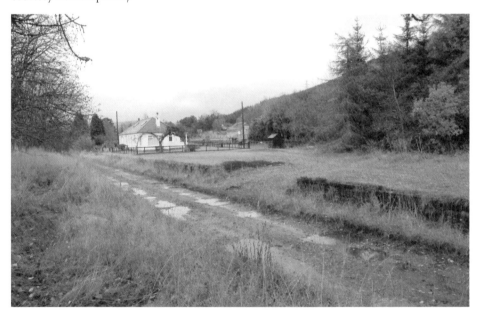

This 2012 view from a similar standpoint shows the remains of the loop as they are today. The dip in the platform on the right is where the tablet catcher was mounted – this can just no more be seen behind the contractor's train view. (Ewan Crawford)

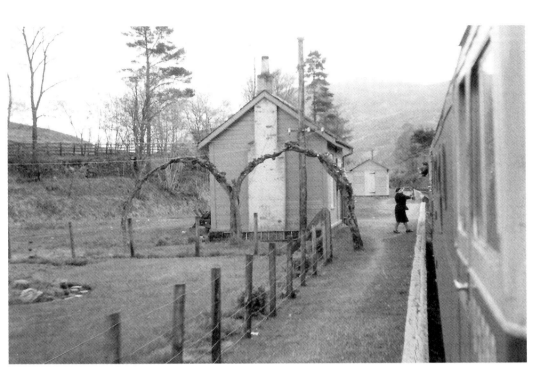

Glenoglehead viewed from a southbound train in 1963. The signalwoman and driver exchange tokens. The timber buildings are now long gone but the artistic arches still exist to this day. (Doug

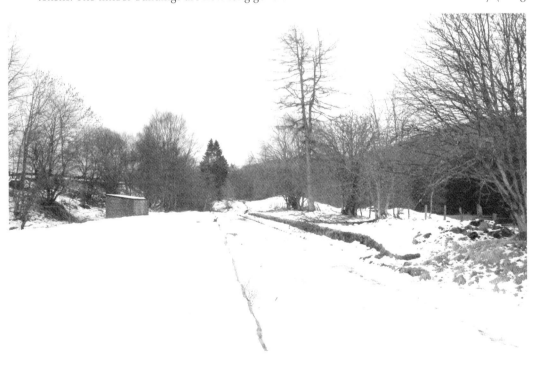

This 2011 view is taken with my back to the station garden and shows Glenoglehead's southbound platform. It's tempting to say it wouldn't take much to re-lay the line here! (Ewan Crawford)

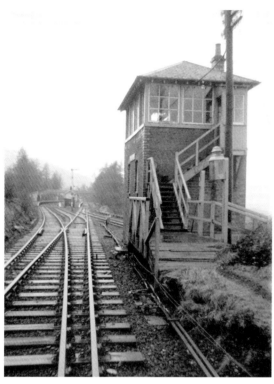

Killin Junction

A view west towards the junction from Killin Junction (formerly Killin Junction East) signal box in 1966, with the Killin branch coming in from the right. This was the only signal box in latter years as the west box closed in 1935. The photographer found a rusting oil lamp, engraved 'Killin East Junction', abandoned on the ground near here. (David Spaven)

This 2012 view was taken to contrast with David's 1966 view. Nothing interesting was found on the ground on this visit! (Ewan Crawford)

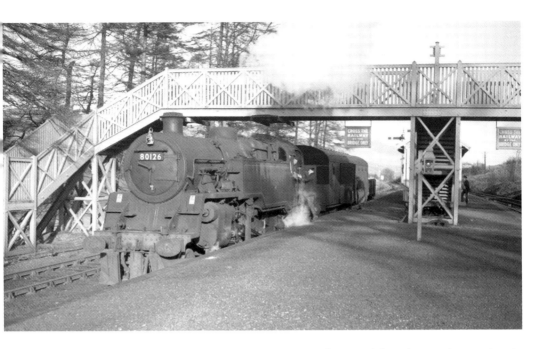

80126 arrives at Killin Junction in the mid-1960s. It was the use of these heavier locomotives in the last years of the branch which led to re-laying of the line. The junction itself is beyond the footbridge and station building. (The late Robin Barbour, courtesy Bruce McCartney)

The building and footbridge are long gone, but something of the station can be seen today. Trees which covered part of the site in the 1990s have been felled and it's easier to make a 'now' photograph today. Only the westbound mainline platform has survived intact, being made in concrete; the others are reduced to slopes. (Ewan Crawford)

Without the footbridge it is difficult to take a 'now' view, but this view west does at least show the remaining concrete platform. (Ewan Crawford)

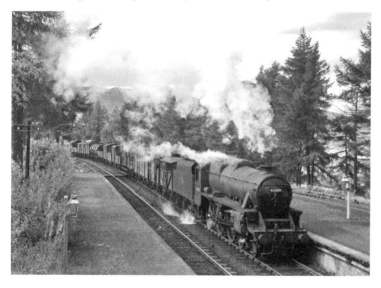

In 1960 45389 passes east through Killin Junction with a lengthy freight. Although none of this freight is likely to have originated between Crianlarich and Killin Junction this shows that a high volume of freight still ran on the line at this date. (Colour Rail/ Friends of the West Highland Lines)

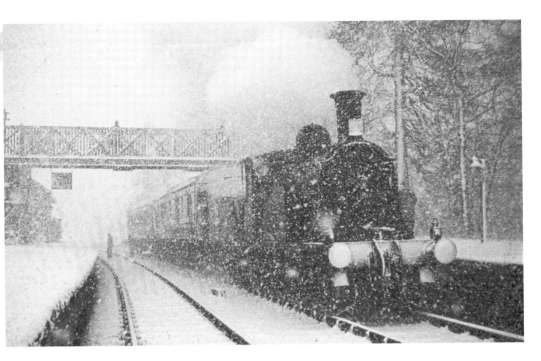

CR 123 meets wintry weather at Killin Junction. This 1963 tour was famous for the heavy downpour of snow which occurred, leaving those on board wondering if the train was going to make it through! Note the vintage Caledonian Railway coaches, now in preservation at Bo'ness. (John Robin)

A similar perspective today. Very little indeed remains of the westbound platform but many's the time I've used the eastbound platform to brew up tea on a walk along the former line. (Ewan Crawford)

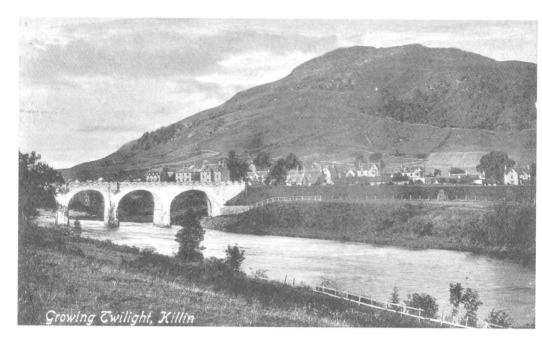

Growing Twilight, Killin

Dochart Viaduct

Now we follow the former Killin Railway to Loch Tay. This postcard shows Dochart Viaduct from the east side with the town of Killin beyond. The contractor underestimated what was involved in building this viaduct, which was unfortunately to lead to his bankruptcy. (P. Ross Killin V&S Ltd)

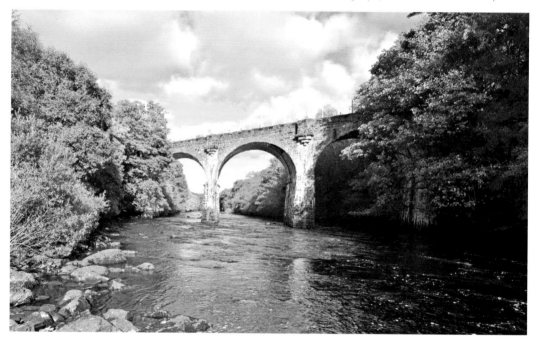

The viaduct still stands today. This is the west side, looking to Loch Tay. The former branch is now a very pleasant walk; one can take a circular walk taking in this viaduct, the former Killin station and the nearby Falls of Dochart. (John Gray)

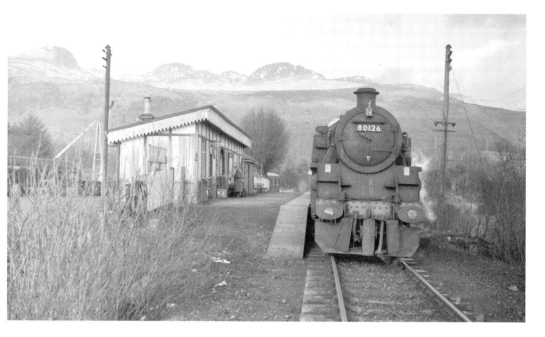

Killin

BR Standard Class 4 No. 80126 stands at Killin in the 1960s with the 1.52 p.m. train to Killin Junction. (The late Robin Barbour, courtesy Bruce McCartney)

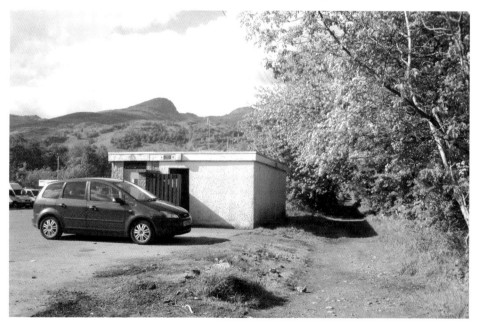

Killin station is not the picturesque location it once was, with a toilet block where the station building stood and a council depot in the goods yard. However, over forty years after closure in 1965, the trackbed towards Loch Tay still makes an excellent country walk. (Mark Bartlett)

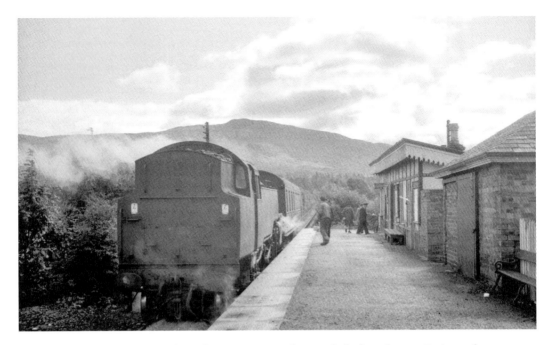

80028 stands at Killin with the branch train in 1965 a few weeks before closure. Trains no longer carried passengers to Loch Tay and this was a terminating service. (Kenneth Gray)

Standing on what was the trackbed this is the view looking to Killin Junction in 2011. Nothing remains of the platform or buildings. However, a little way behind the camera a girder bridge still stands over the River Lochay. (Ewan Crawford)

Loch Tay

80093 runs round the preserved Caledonian Railway coaches at Loch Tay on 12 April 1963 prior to returning to Killin with Scottish Rambler No.2. A coal wagon often sat on the loop line, after 1939, but when a train was brought to the station, this was pushed back to the shed. (John

For comparison, this is a 1990 view looking to the locomotive shed. The station building still stands and is a now a house. (Ewan Crawford)

No. 55126, a 0-4-4T McIntosh, is seen here at Loch Tay, Killin shed, on 6 July 1955. These locomotives were used for many years on the Killin branch until being replaced with heavier locomotives just before closure. (The late Ian Peddie, courtesy Donald Peddie)

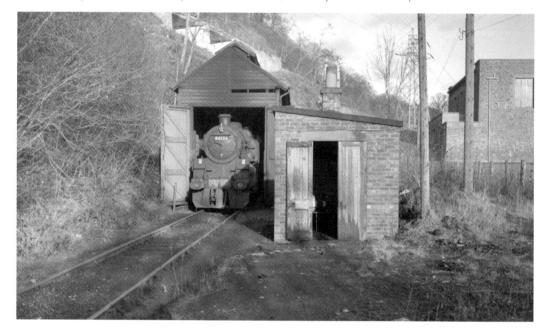

BR Standard Class 4 No. 80126 in the single road wooden locomotive shed at Loch Tay in February 1964. Beyond the shed is a hydroscheme which transformed the landscape when built in the 1950s. Nothing remains of the shed today; its site is now a house. (The late Robin Barbour, courtesy Bruce McCartney)

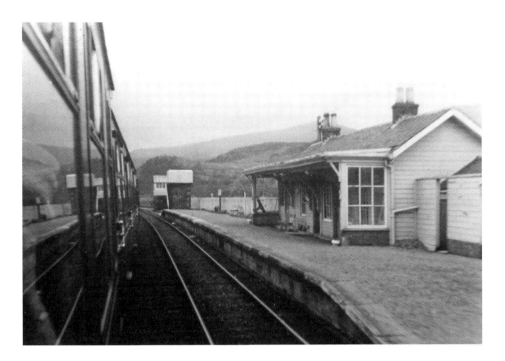

Luib

We now return to the main line. A 'Six Lochs Land Cruise' passes west through Luib station in May 1964. This tour followed a route with views of Loch Lubnaig, Loch Earn, Loch Tay, Loch Lomond, Loch Long and the Gare Loch. Stuart recollects, 'The usual times on the counter-clockwise route were 2 hours at Callander, 2 hours at Killin and 1 hour at Crianlarich.' One of the small C&O signal boxes can be seen just past the water tank. The view looks west. (Stuart Rankin)

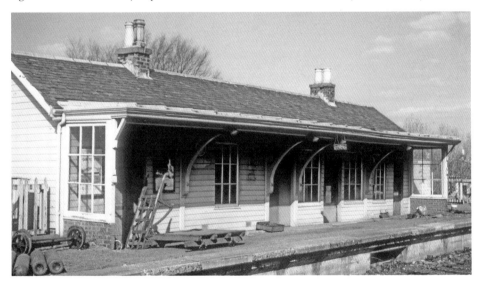

Track lifting at Luib is reaching completion in what is thought to be April 1967. The building hasn't survived but the edges of the platforms can still be traced. For eastbound trains, Luib was the start of the climb to Glenoglehead whereas a good speed could be attained on the route west to Crianlarich. (Stuart Rankin)

This view is from the east end of Luib station, taken from the site of the signal box looking east at the water tank and infilled platforms. The station site is now the Dochart Caravan and Holiday Park (www.glendochart-caravanpark.co.uk). (Ewan Crawford)

Portions of platform edges remain on the site, now finding other uses in the gardens of the caravan site! (Ewan Crawford)

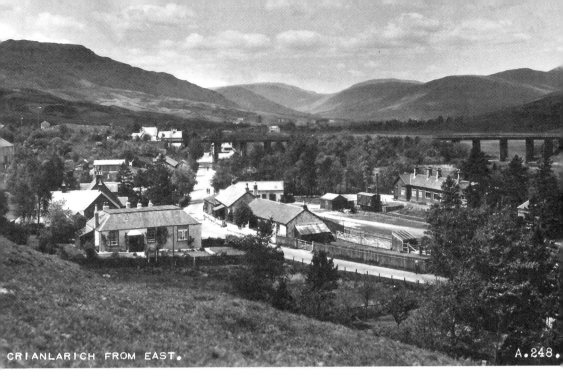

CRIANLARICH FROM EAST. A.248.

Crianlarich
This 1900s view is over Crianlarich station from the east. The rear side of the station building and goods yard can be seen. (Valentine's postcard)

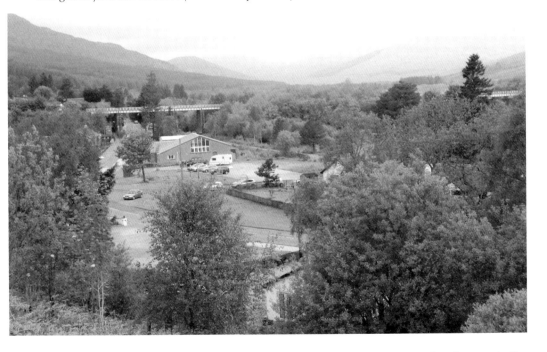

Tree growth makes a modern view difficult; however, this is the view today from a similar standpoint. (Ewan Crawford)

51

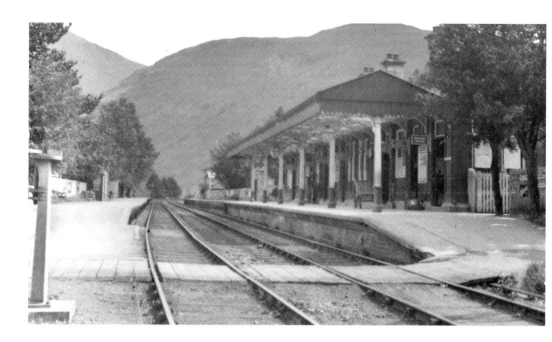

The tablet catcher is prominent in this 1913 view of Crianlarich station viewed from the west level crossing. The loop was taken up from the westbound platform in 1921 as another loop had been opened just to the west at Crianlarich Junction (the junction with the West Highland Railway), in 1897. Another diminutive signal box can be seen distant left. (J. B. Sherlock)

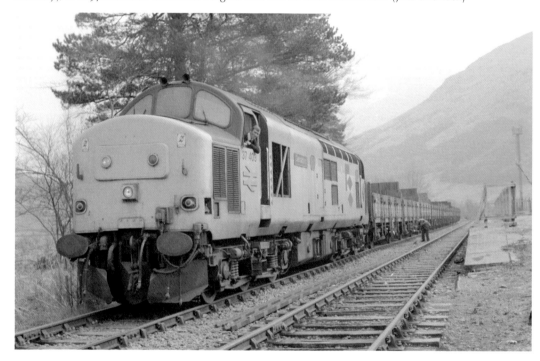

37 403 drops off an empty timber train at Crianlarich Lower in 1990. The loop was reinstated here in 1967 when the loop at the junction was lifted. (Ewan Crawford)

Crianlarich Junction

For a 'before' view of Crianlarich Junction see John McGregor's *West Highland Line Through Time,* also by Amberley (page 42). This view shows a 37 running down the West Highland Railway's connection to the Callander and Oban in 1988. This spur was used simply to exchange freight until coming into regular use when the Callander route closed although some passenger trains were routed this way from 1939 on. (Ewan Crawford)

This was the same view in the winter of 2012. The line to Crianlarich's timber depot was cut back when the depot closed and, although still in place, is reverting to nature. This is a far cry from when this was a traffic exchange point with loops on both lines, sidings and two signal boxes.(Ewan Crawford)

Tyndrum Lower

This postcard view of Tyndrum station looks west in 1913, when the passing loop and buildings were still in place. The original terminus here was out of shot to the right and behind the camera was a signal box like that at Dalmally. (J. B. Sherlock)

This 1994 photograph is for comparison with the 1913 view. Since taken, tree growth has made it difficult to see what little remains of the former westbound platform. 'Lower' was added to the station name in 1953. (Ewan Crawford)

'You're keen,' said the guard of this Oban bound service. I have to agree really! For much of the year, with shorter hours of daylight, trains run on the West Highland Lines in the dark, the few passengers missing out on the wonderful scenery. (Ewan Crawford)

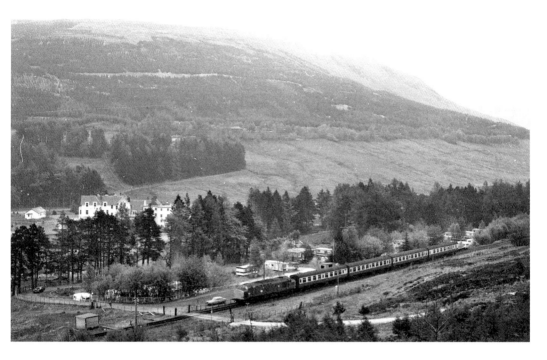

A Class 37 stops at Tyndrum Lower with a train for Oban in August 1984. In the centre distance Upper Tyndrum, on the West Highland Railway, is visible. (John Gray)

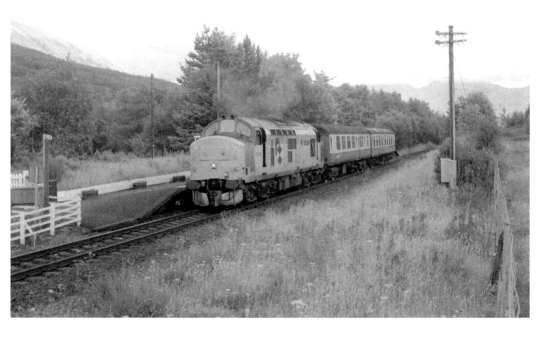

37 403 pulls away from Tyndrum Lower in the summer of 1989. This was one of the locomotive hauled trains which supplemented Sprinters in the summer of that year. (Ewan Crawford)

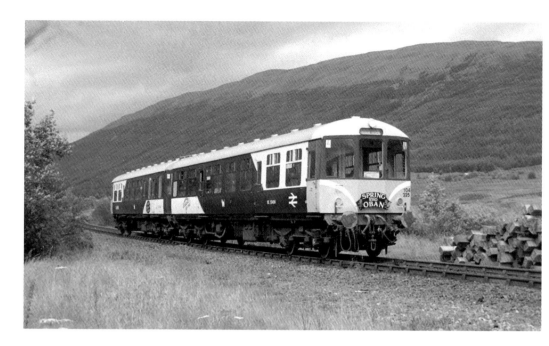

In the mid-1980s the 'Mexican Bean' was used for Sunday excursions between Oban and Crianlarich. This imaginative idea had some echoes, perhaps, of the local Dalmally to Oban service which the line once carried. Although the service was only to last for a short period, it's notable that all the services on the Oban line are today operated by Sprinter DMUs – it was the shape of things to come. (Bill Roberton)

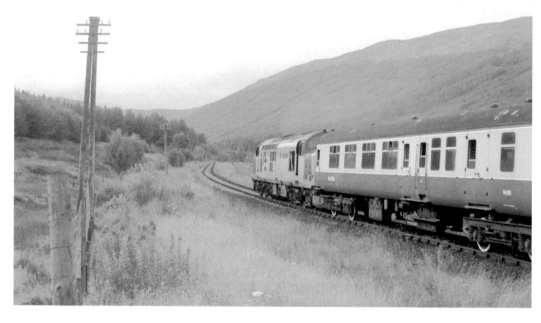

There was still the occasional 37-hauled train to Oban after introduction of the Sprinters. Here, 37 403 heads west from Tyndrum Lower at the same location the Mexican Bean occupied four years previously. (Ewan Crawford)

In 1991 a Sprinter heads west from Tyndrum into Glen Lochy. (Ewan Crawford)

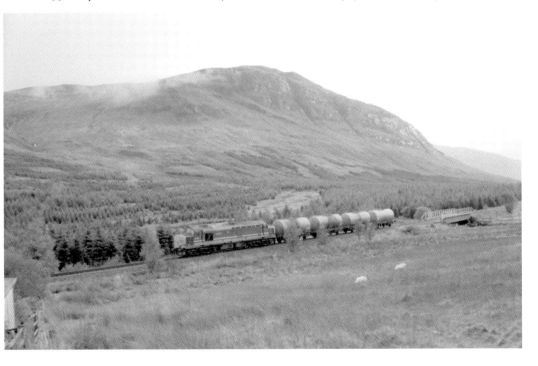

An oil train from Oban pier is seen heading east through Glen Lochy in 1991. This particular train was to be dropped off in the siding at Arrochar and Tarbet with the locomotive returning to Oban in the evening. (Ewan Crawford)

Dalmally

Dalmally station with shed viewed from the south-east in a 1906 view. It is not possible to take a photograph from a similar standpoint today as a result of tree growth. The shed was extended and a 'seam' can be clearly seen in this view. There are coal wagons in the siding adjoining the shed. (George W. Daly, Dalmally)

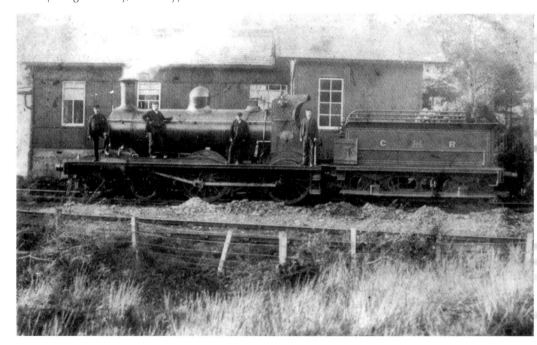

A lovely old photo of a rebuilt original 'Oban bogie' at Dalmally shed. The building behind the engine stood on the westbound platform. (The late Dugald McPhail Collection, courtesy Alasdair Renfrew)

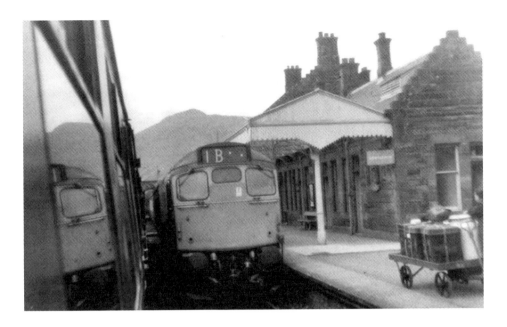

An unidentified Class 27 draws in to Dalmally on a 12.25 p.m. Oban–Queen Street in August 1968, crossing the 10.35 a.m. DMU from Queen Street. Interesting to note what is being loaded on to that service and the '1B' headcode on the loco, signifying a Glasgow destination. (Hamish Baillie)

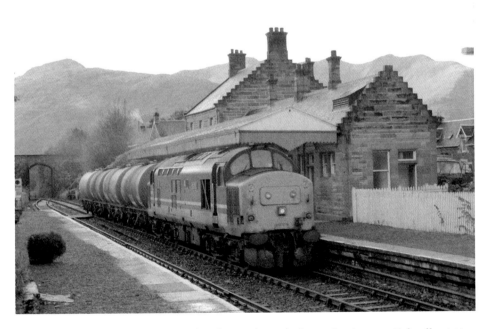

A 37 with oil tanks from Oban pier heads east through the station in 1991. Dalmally station still has its heron fountain, which is out of shot to the left. The building is now a craft centre specialising in felt-making (www.heartfeltbyliz.com). (Ewan Crawford)

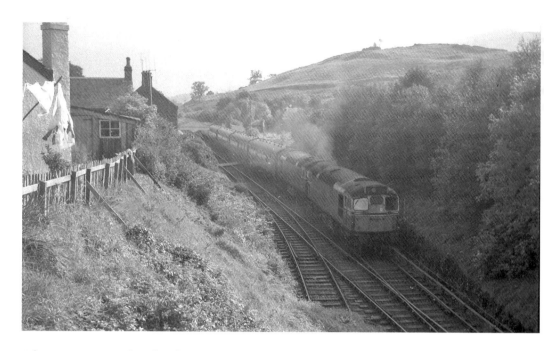

A late-running train for Oban leaving Dalmally on 27 September 1965. This was the day of the infamous landslip in Glen Ogle which resulted in the final closure of the route. It is not known if this train was the train turned back at Luib or another diverted via Sighthill yard and the West Highland Line as a result of the blockage. (Colin Miller)

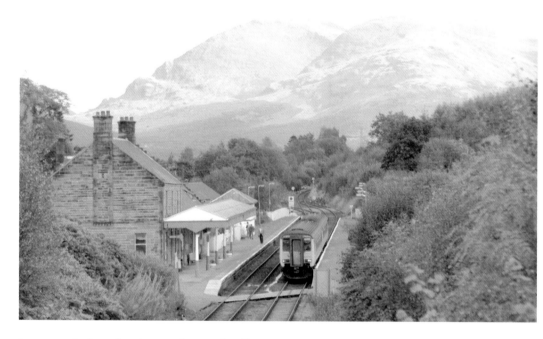

In 1991 a Sprinter heads west from Dalmally viewed from the bridge at the west end of the station. (Ewan Crawford)

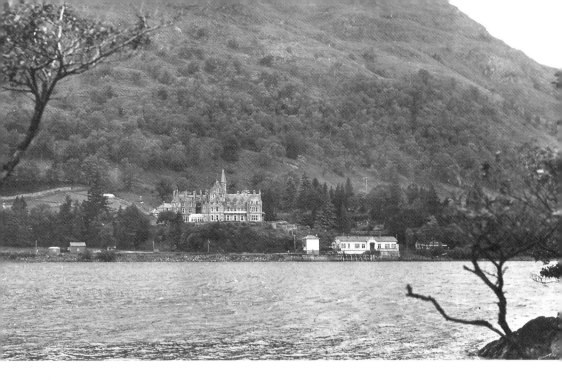

Loch Awe

Loch Awe Hotel was built around the same time as the railway by the Marquis of Breadalbane. This immediately post-Second World War view looks across Loch Awe to the hotel with the station just below. There was an unsightly luggage lift between the hotel and the station for many years, removed in the 1930s. (Postcard, publisher unknown)

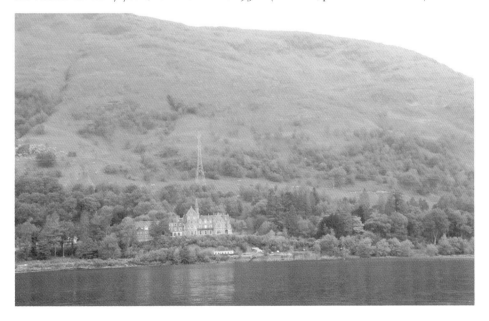

Although the station has lost its buildings the hotel still stands and not too much has changed as seen in this 2013 view. A Mark 1 carriage beside the station provides accommodation (www.scotrailholiday.com) (Ewan Crawford)

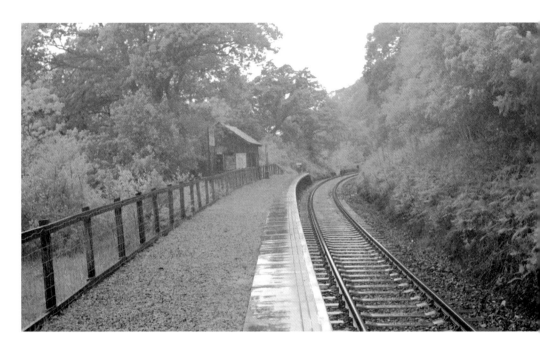

Falls of Cruachan
The original station closed in 1940. When the station re-opened the original building still stood, out of use, and this is it seen in 1990. The building is similar to that which originally stood at Kingshouse Platform. (Ewan Crawford)

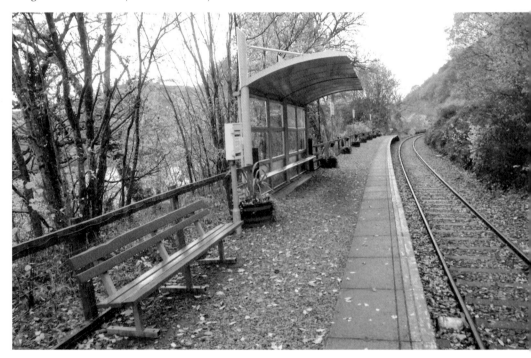

A snazzy new shelter now exists at this halt making up for a long period during which there was no shelter at all. (Ewan Crawford)

Anderson's Piano, which was built to detect falling boulders, has been given an overhaul. This is the view west from beside Falls of Cruachan station, showing signal and protective screen in 2012. (Ewan Crawford)

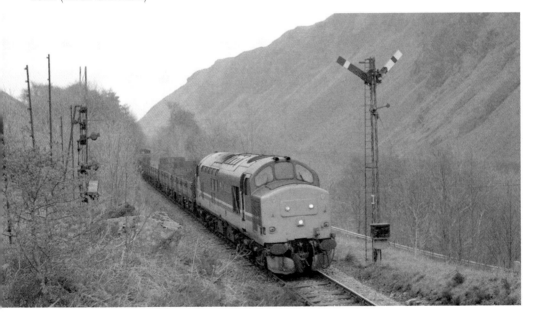

Pass of Brander
37 405 is seen heading west through the Pass of Brander with a timber train in 1990. (Ewan Crawford)

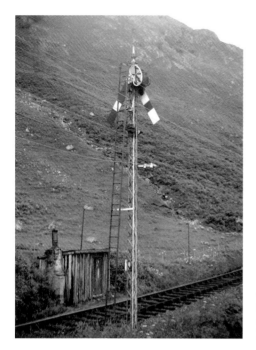

An August 1951 view of the Caledonian Railway signals in Pass of Brander in their original condition. (The late Ian Peddie, courtesy Donald Peddie)

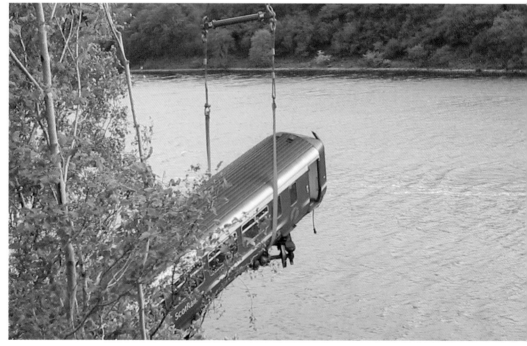

On 6 June 2010 the 6.20 p.m. Glasgow–Oban service hit a large boulder on the line above Loch Awe. The rocks had rolled down from just above the track, below the fencing. None of the sixty passengers were injured and were safely evacuated by driver Willie Dickson and local conductor Angus McColl who later received awards for their actions. The A85, immediately below, was closed for a week while a heavy lifting crane was positioned; that part of the road runs on a viaduct. The recovery of the coach on 11 June is seen here. (Doug Carmichael)

Taynuilt

37403 waiting for a crossing at Taynuilt station in 1989. The station building was not used at the time but would become a brewery and pub shortly afterwards. (Ewan Crawford)

Nearly an hour later, 37 409 *Loch Awe* passes with The West Highlander. The direction of the loop was reversed, to give easier access to the sidings, giving rise to trains being the wrong way

In 1990 the signal box was relocated from the west end of the station to the east end to be used as a waiting room for passengers. (Ewan Crawford)

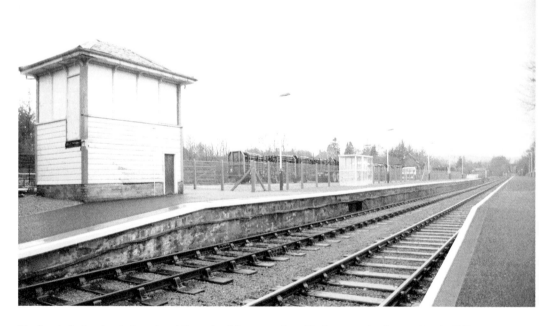

Timber is being loaded at the sidings in this 2001 view. Unfortunately the station building was burned down and demolished. The signal box (which is listed) is no longer a waiting room. (Ewan Crawford)

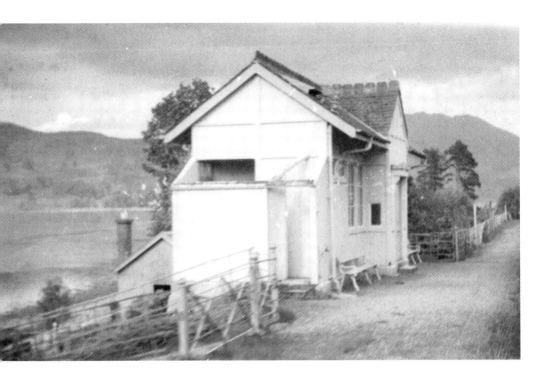

Ach-na-Cloich
Ach-na-Cloich viewed from an eastbound train in 1963. (Doug Carmichael)

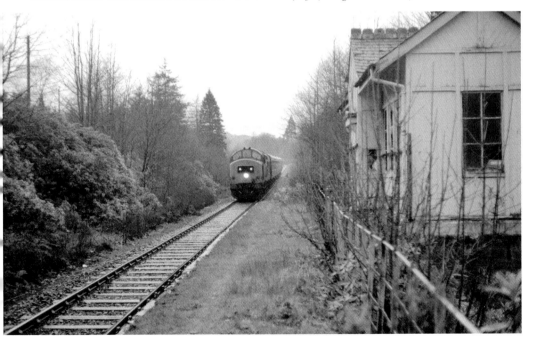

An eastbound 37-hauled train passes at speed through Ach-na-Cloich. Unfortunately, the station building, the last timber station building on the west portion of the line, has been demolished. (Ewan Crawford)

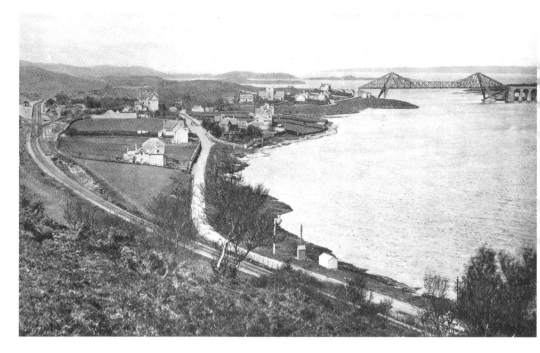

Connel Ferry

This high viewpoint at the east end of Connel Ferry station shows the alterations made to the station for the Ballachulish branch while still new. The Connel Ferry Bridge can be seen on the right. The date is probably around 1903. (Valentine's postcard)

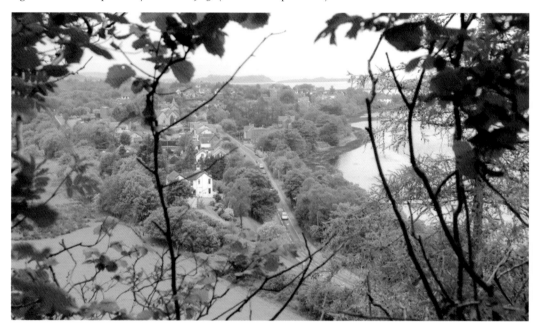

It's not easy to take a similar photograph from this cliff today owing to tree growth. The former goods yard, now disused sidings in an oil depot, can be seen to the right of the station. (Ewan Crawford)

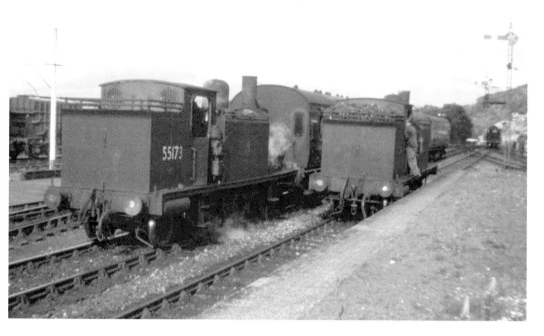

Two ex-Caledonian Railway 0-4-4 tanks at Connel Ferry station on 1 September 1960, with 55173 on the left. (The late Frank Spaven, courtesy David Spaven)

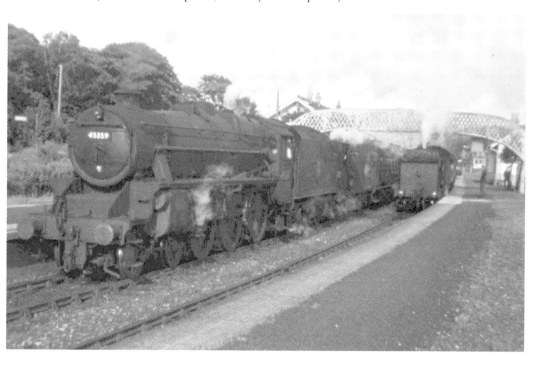

Black 5 No. 45359 and two tanks occupy the platforms at Connel Ferry station on 1 September 1960. (The late Frank Spaven, courtesy David Spaven)

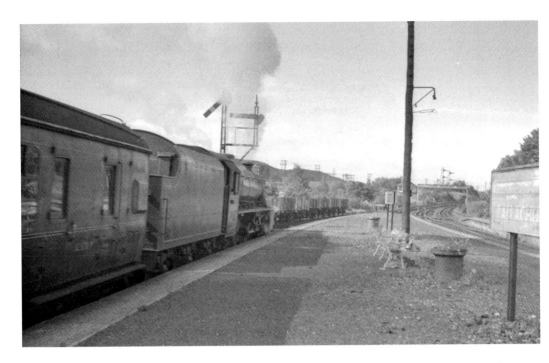

Black 5 No. 45084 of Stirling shed prepares to leave Connel Ferry in September 1960 on the last leg of its journey to Oban. The board on the right reminds passengers to alight here for the connecting service to Ballachulish. The train is thought to comprise the 6.50 a.m. ex-Princes Street and 7.55 a.m. ex-Buchanan Street. (Kenneth Gray)

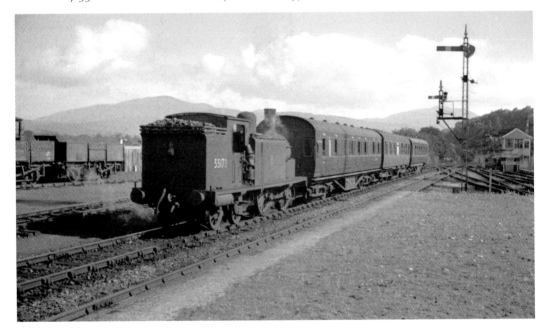

McIntosh 0-4-4T No. 55173 approaching the platform at Connel Ferry from the east with the stock of the Ballachulish branch train, most probably the early afternoon service. The date is 9 September 1960. The following photographs are of the Ballachulish branch. (Kenneth Gray)

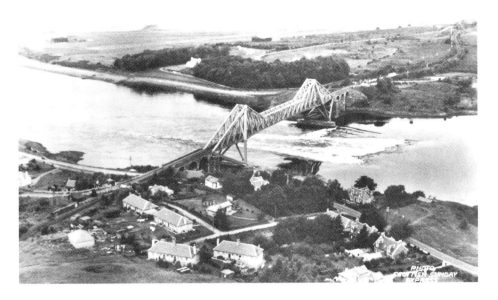

Connel Ferry Bridge
An aerial view of Connel Ferry Bridge looking north which also shows North Connel Halt at the top of the image. The Falls of Lora are a tidal feature seem to the right of the bridge.(*Scottish Sunday Express* postcard)

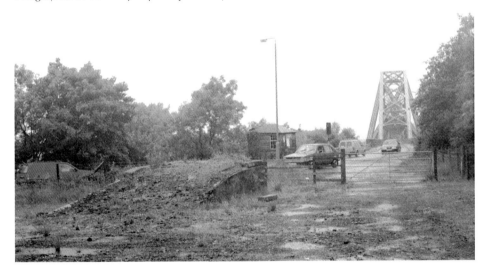

Looking towards the Connel Bridge with the former approach to Connel Ferry station behind the camera. This would have been the northern junction of a triangular layout at Connel had the west to north curve been installed (this was railway No. 2 in the Act, of which only a road overbridge and some earthworks were built). Of particular interest is the old loading ramp. This ramp was used to load cars onto a rail-mounted charabanc's trailer for a short haul over the viaduct. The Connel Bus charabanc, formerly used between Clarkston station and Eaglesham, operated a fairly intensive service between 1909 and 1914 – ten round trips a day from Connel Ferry to North Connel with four of these running on to Benderloch. Beyond the ramp is the old hut from a later period following alterations to the bridge to allow cars to cross when not in use by trains. (Ewan Crawford)

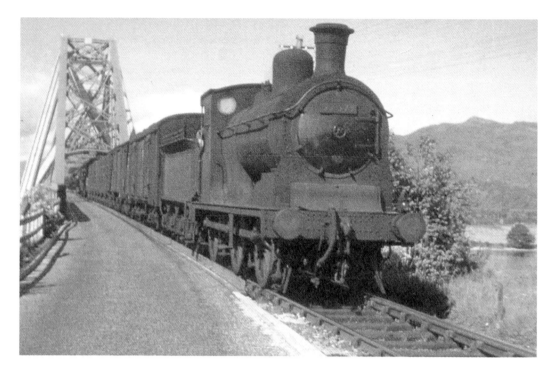

The branch goods from Ballachulish rolls off the south end of Connel Ferry Bridge in September 1960 hauled by an ex-Caledonian 0-6-0. (The late Frank Spaven, courtesy David Spaven)

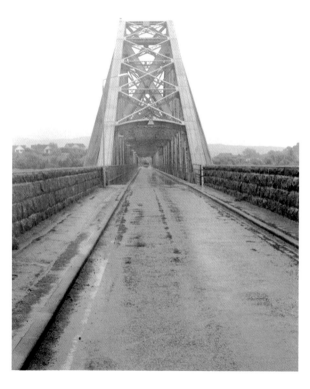

This bridge is now a road bridge and this 1990 view shows the same approach. (Ewan Crawford)

Benderloch

A convenient hill right by Benderloch station was used to photograph the Post Office and station. The view looks south. This station was typical of the two platform stations on the line (Benderloch, Appin, Duror, Kentallen) each of which had a building, signal box and shelter of the same design. (Valentine's postcard)

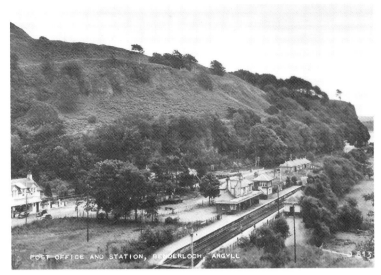

POST OFFICE AND STATION, BENDERLOCH, ARGYLL

The platforms survived intact into the 1987s and even the ballast was well preserved. This is a 1987 view looking south. (Ewan Crawford)

The trackbed was infilled in the 1990s and is now totally overgrown, except at the north end of the site. A view from the convenient hill is not possible today due to tree growth. (Ewan Crawford)

73

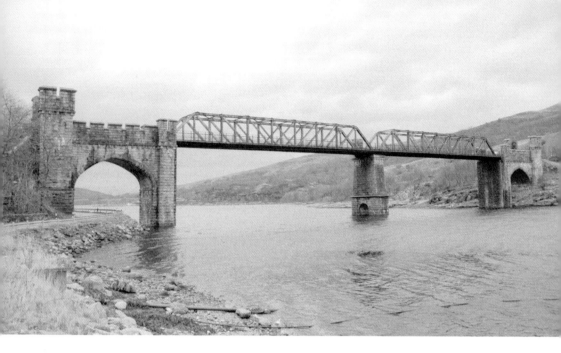

Creagan Bridge
This was the bridge as it was in 1992, still clearly a former rail bridge. The view is from the east side. (Ewan Crawford)

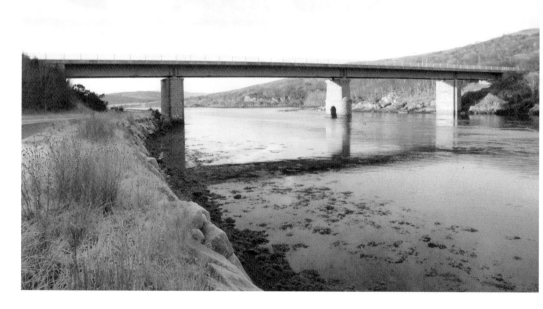

The bridge has been converted into a road bridge. This is the view today of the road bridge from the east side. (Ewan Crawford)

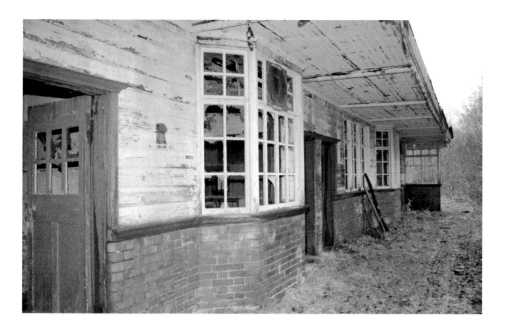

Creagan

Creagan was different to the other stations on the line, having an island platform. After closure Creagan station reverted to nature. In the 1990s the site owners began the long, laborious task of cutting back the vegetation and then repairing the building. This is the overgrown main platform (not on a curve) looking south. (Ewan Crawford)

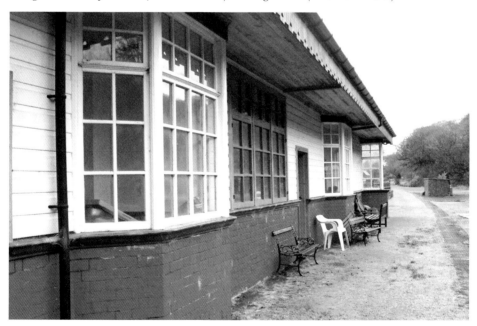

This shows the building in its repaired condition. This is a view of the curved platform side, looking north. For island platform stations built after 1900 it was common to build one platform straight, for non-stop trains, and one curved for stopping trains. The station is part of the Appin Holiday Homes site (www.appinholidayhomes.com). (Ewan Crawford)

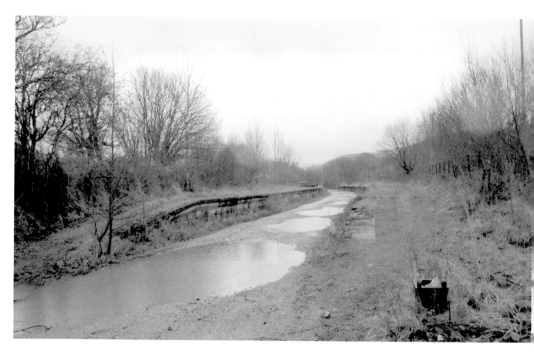

Appin

In the 1990s it was possible to walk some of the Ballachulish branch before conversion into a footpath. This is the north end of Appin as it was in 1996 before being tidied up and made into a footpath. Note the signal post base on the right. (Ewan Crawford)

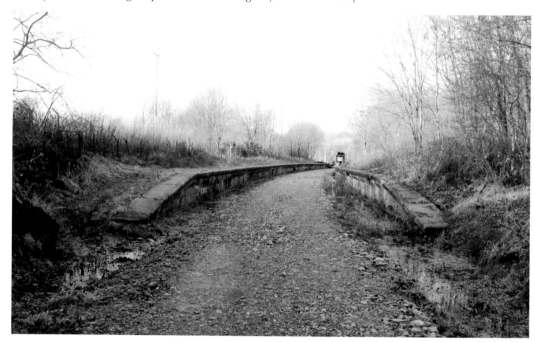

In 2008 the branch was converted into a long distance foot and cycle path. This shows the south end of the station immediately after a new surface had been laid. (Ewan Crawford)

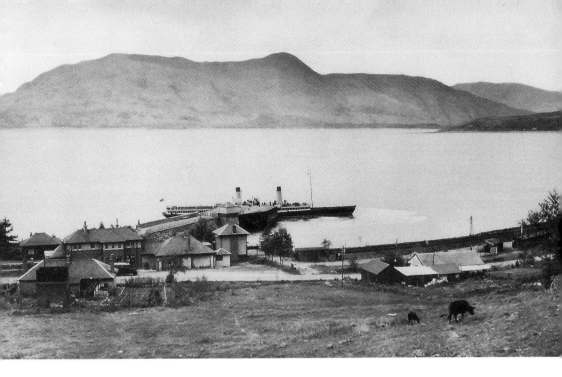

Kentallen
Kentallen Pier seen from the hillside when the pier was still visited by steamers for Fort William.
(Valentine's postcard)

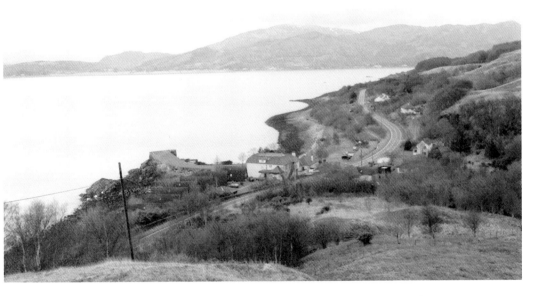

Due to housing development it's not easy to take the same view today. Instead here is a slightly
different view taken from the south in the 1990s. The building has been extended since this was
taken. (Ewan Crawford)

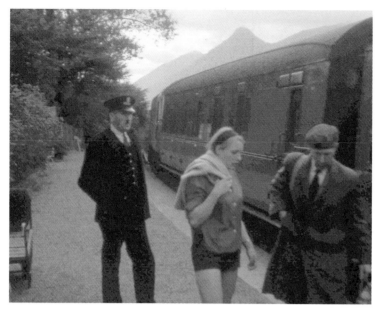

Ballachulish Ferry
The guard of a Ballachulish-bound train watches passengers disperse at Ballachulish Ferry station, thought to be in the summer of 1965, with the mountains of Glencoe in the distance. The station closed along with the rest of the branch in March 1966. (The late Frank Spaven, courtesy David Spaven)

This was the scene in 1995 before the old railway was converted into a footpath. (Ewan Crawford)

Today the railway is a footpath, although the portion from Ballachulish Ferry to Ballachulish was robbed away for road building. A signal post stands by the road not far from Ballachulish, but I'm afraid it's not original! (Ewan Crawford)

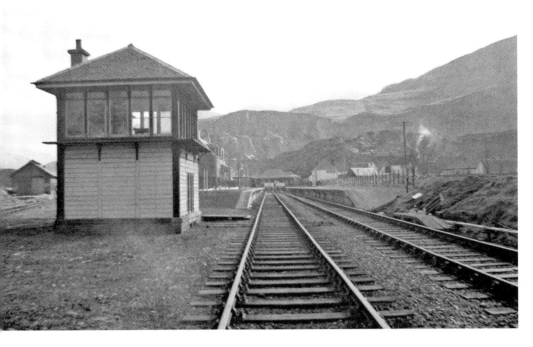

Ballachulish
Looking towards the buffer stops (and the distinctive slate quarries beyond) at Ballachulish station at Easter 1966, just two weeks after the last train had departed. (David Spaven)

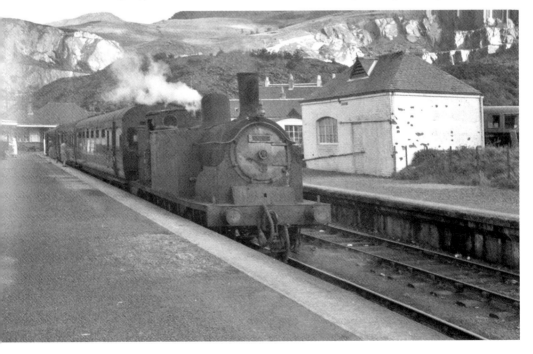

The afternoon branch train awaits its departure time from Ballachulish terminus on 9 September 1960. The locomotive is a Caledonian 0-4-4T No. 55173. (Kenneth Gray)

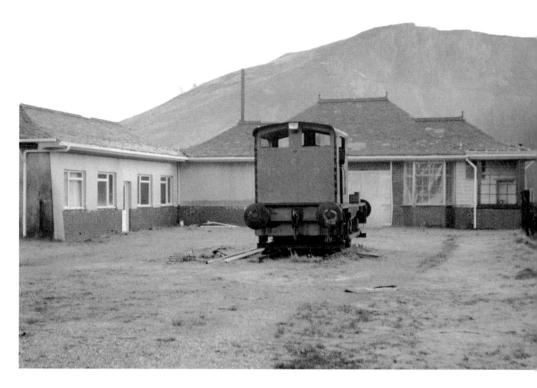

An industrial locomotive found its way to the former station site in the 1980s. The platforms had been infilled and the station building was in use as offices for a garage. (Ewan Crawford)

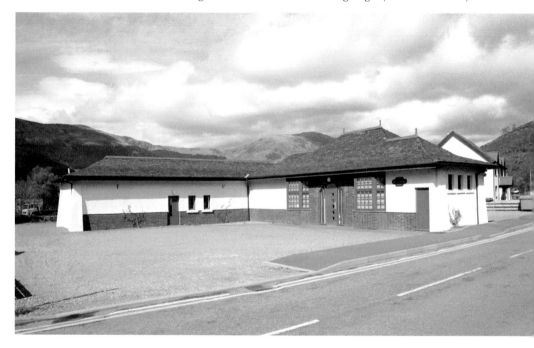

The station building has been beautifully restored and is now in use as a health centre. (Ewan Crawford)

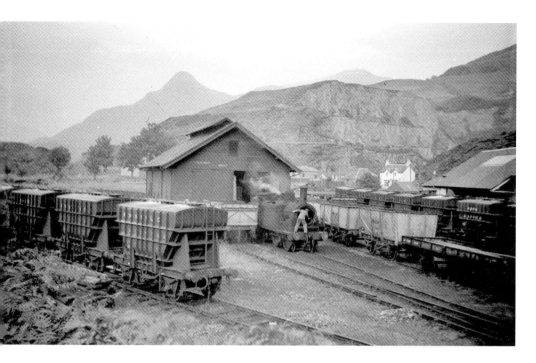

The locomotive shed at Ballachulish in August 1960, with McIntosh 0-4-4T No. 55224 receiving attention in the yard. The shed was officially closed in March 1962 with complete closure of the branch taking place in 1966. Note the alumina wagons in the yard which are for the smelter at Kinlochleven. (The late Robin Barbour, courtesy Bruce McCartney)

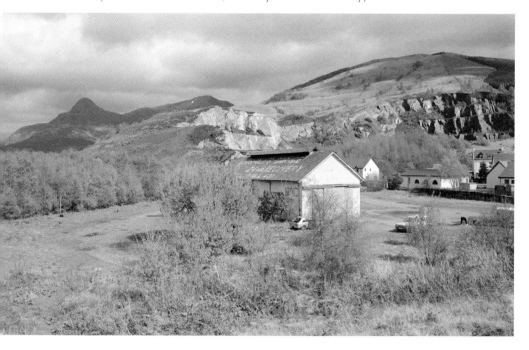

A similar view taken in 1995 with the slate quarries prominent in the background. (Ewan Crawford)

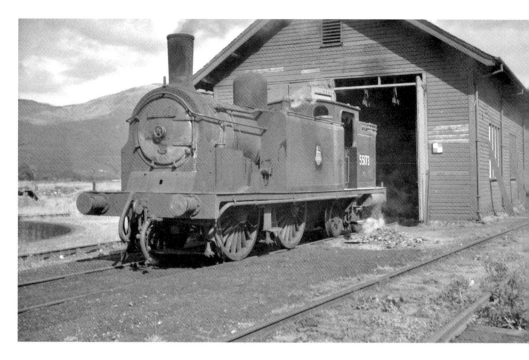

Ex-CR 0-4-4T No. 55173 looking relaxed on shed at Ballachulish in September 1960. The line between Connel Ferry and Ballachulish was closed completely in 1966. (Kenneth Gray)

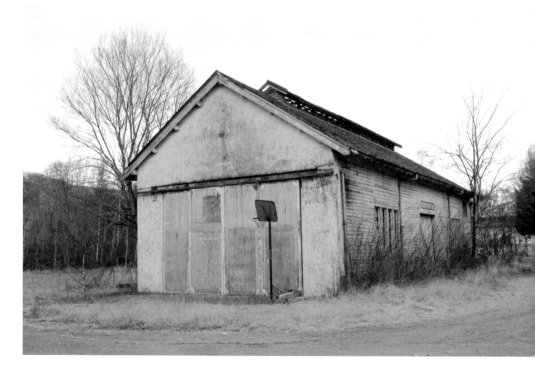

Although the shed is slowly mouldering away it is still standing. Perhaps worthy of relocation to a suitable preserved railway? (Ewan Crawford)

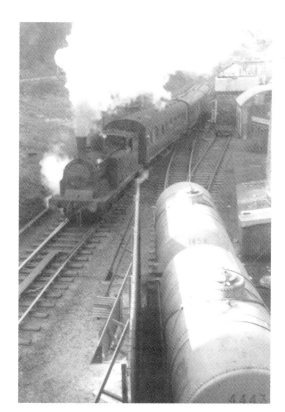

Oban Goods and Shed
Returning to the main line, Caledonian 0-4-4T is seen climbing past Oban Junction on the 4.55 p.m. to Ballachulish. (Alasdair Renfrew)

Oban Goods Junction still remained to provide access to an oil depot in 1990. (Ewan Crawford)

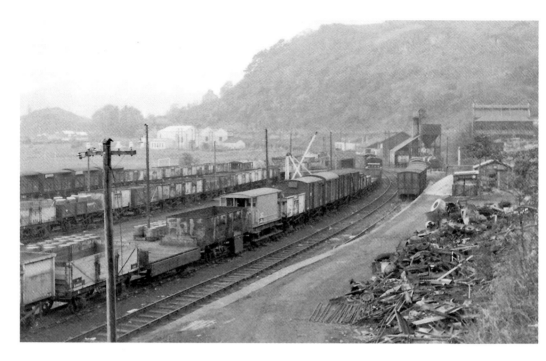

While not the most attractive location along the railway these two views show the less photographed Lochavullin yard in Oban. This overview of the Lochavullin yard looks to Oban Goods Junction and the shed. This is a 1963 view and it must be said that this was still a busy yard at that time. (Doug Carmichael)

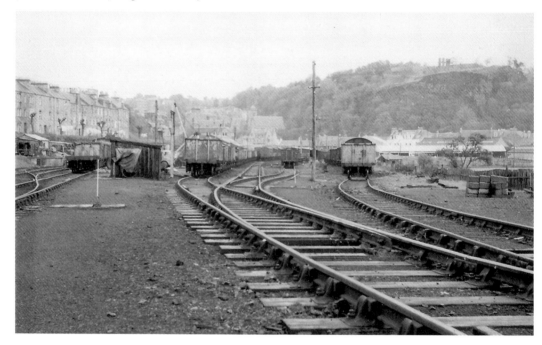

This second view by Doug Carmichael looks in the reverse direction, showing just how busy the sidings were here in 1963. (Doug Carmichael)

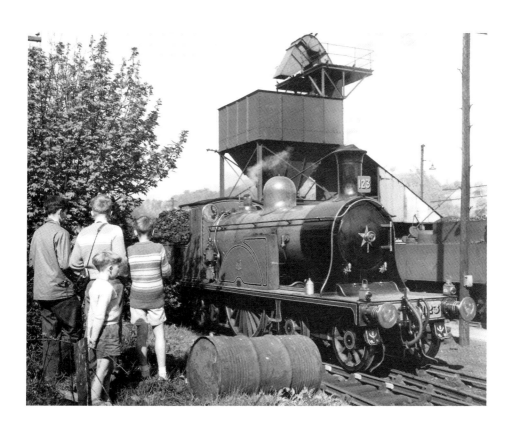

Several young enthusiasts look on as CR 123 is turned on the Lochavullin turntable. Also on this train was NBR 256, although rumour has it that only 123 was polished on arrival at the shed! (Doug Carmichael)

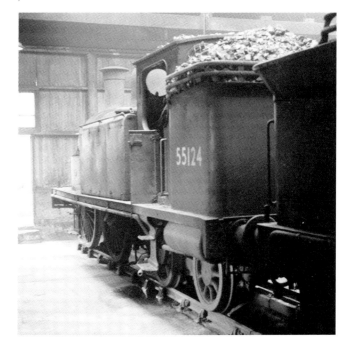

This was taken inside Oban shed. No. 55124, the very last of Lambie 0-4-4T locos, is seen on 1 July 1961. (The late Ian Peddie, courtesy Donald Peddie)

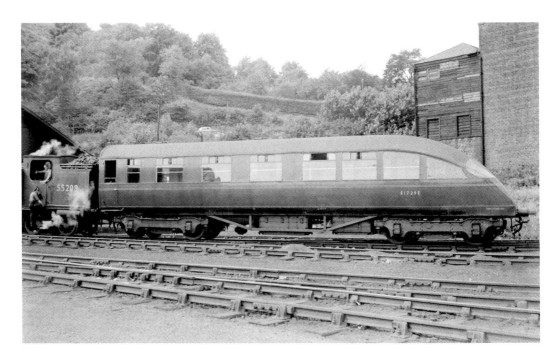

Observation car E1729E is being turned at Oban shed on 16 August 1957. The service to Oban started in spring 1957 with this Coronation Train car, built by Metro-Cammell in 1937. 55208 CR 0-4-4T 2P is to the left. (The late Ian Peddie, courtesy Donald Peddie)

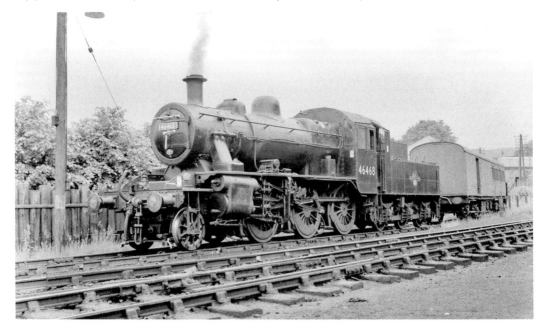

No. 46468, a 2MT, is at Oban Shed on 1 July 1961, with its chimney cracked! These mixed traffic locomotives were very suited to the line having a very low axle loading. (The late Ian Peddie, courtesy Donald Peddie)

Oban shed closed in 1962 and
Lochavullin yard was progressively cu
back. The oil siding seen here was laid
on the site of the former turntable.
This was the only remaining siding at
Lochavullin by the time of this 1990
photograph. (Ewan Crawford)

Sadly the oil siding is overgrown and partly lifted. The goods junction has been taken out of use
but a short section of disused track remains in 2013. (Ewan Crawford)

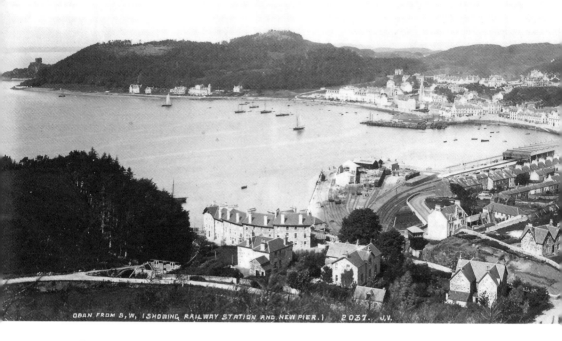

Oban

In this excellent photograph of Oban from above in 1883 we can see that although the passenger station is finished the goods yard is still not completed – the goods shed doesn't have a roof yet. Note the original signal box which was replaced when platforms 3 and 4 were added. (Valentine's print)

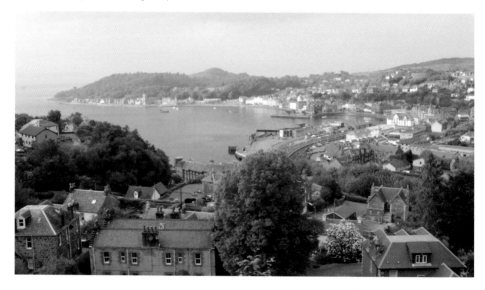

This photograph was taken from the same angle to compare with the classic shot above. Quite a lot has changed. On a positive note the station is still open and ferries use the pier, but the station building has gone and freight has not travelled from the pier for some time. (Ewan Crawford)

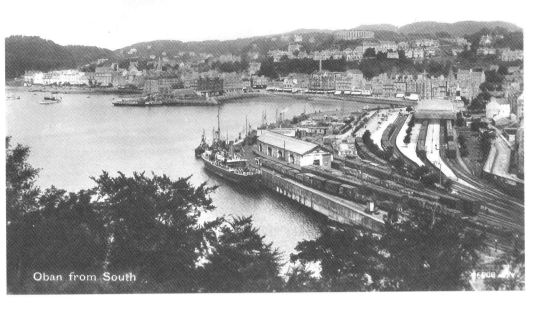

Oban from South

A view of Oban station pier from the south showing quite a lot of traffic at the station. The sidings closest to the platforms were used for empty coaching stock, even up to the last days of locomotives on the line in the 1980s. A steamer can be seen at the MacBrayne's Pier. Oban always had the problem of steamers being divided between the station and MacBrayne's piers. (Valentine's postcard)

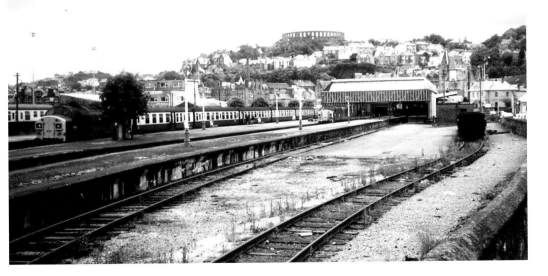

Not a direct comparison, but the relocation of the carriage siding by platform 1 as a goods siding can be seen here. This siding, officially 1A, was sarcastically known as 'Number 5,' a reference to the four platforms at Oban. This shows the station trainshed towards the end of its life. (David

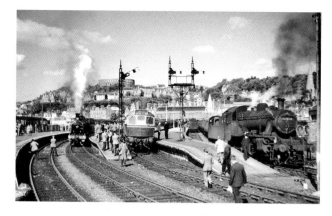

Rather a busy day! This was the day of the visit of CR 123 in 1962. 123, on platform 3, was acting as pilot to NBR 256 *Glen Douglas*. The type 2 is on a service to Glasgow Buchanan Street, with an Edinburgh portion. To the right 46468 is acting as Station Pilot. (Ray G. Oakley / Colour Rail via John Champney)

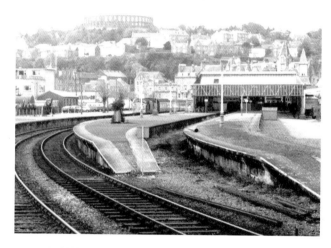

This photograph was taken from a similar standpoint, but with rather less traffic, around 1985. (John Furnevel)

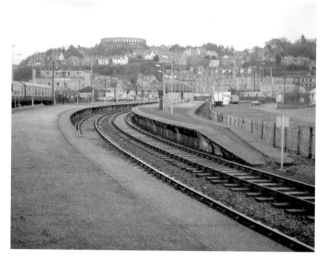

By 1987 the trainshed was gone and the location had become somewhat bleak. (Ewan Crawford)

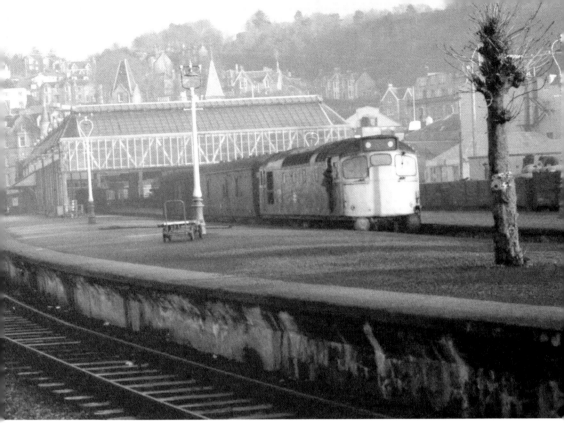

A class 27 shunts parcels vans at Oban in 1977. (John McIntyre)

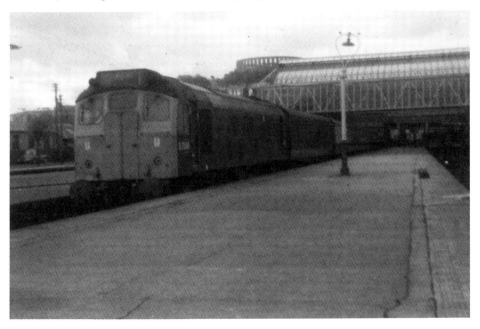

Class 25 waits in Platform 2 on the 5.40 p.m. departure for Queen Street, Saturday 11 May 1968. (Hamish Baillie)

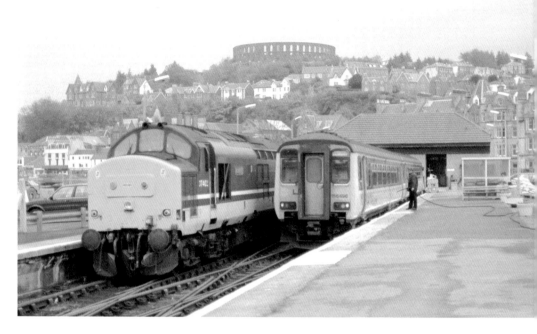

A Sprinter receiving some attention in 1991 with 37 402 probably pausing before running east to pick up timber and oil from Crianlarich. (Ewan Crawford)

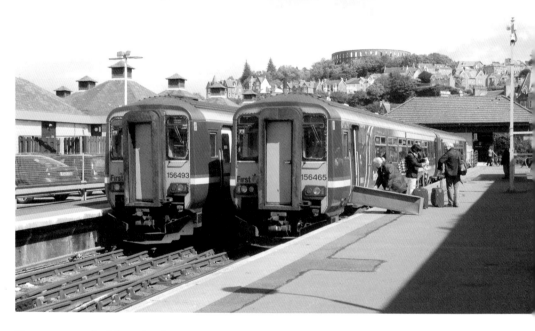

There are new buildings by the station and much of the bleakness has gone. Two Sprinters are seen here in 2011. The trains are still timed to fit with the ferries and I was on my way to the pier to catch the boat to Craignure. This was the last year of operation of the Mull Railway – where can I have been going? (Ewan Crawford)

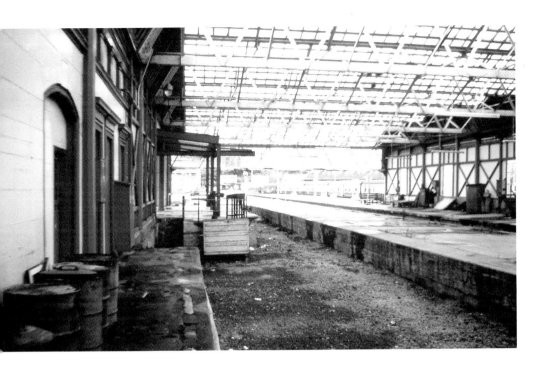

The trainshed survived the lifting of track for a few years, even being spruced up not long before the end. This view is taken looking out from the redundant train shed at Oban in August 1985. Platform 1 was to the left and platform 2 to the right. (David Panton)

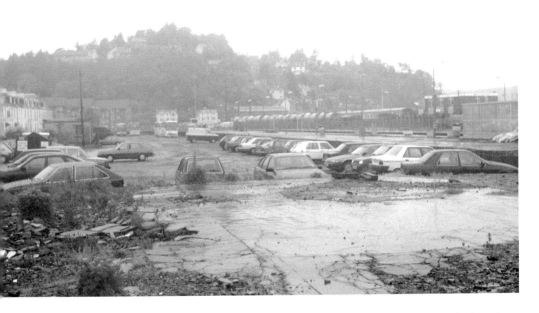

Oban station on a dreich day in 1990. This view looks out from what was the trainshed not long after its demolition and the removal of the platform to make way for a car park. The site is now partly built over and partly car park. The current platforms (right) were built outside the original station to serve the Ballachulish branch. (Ewan Crawford)

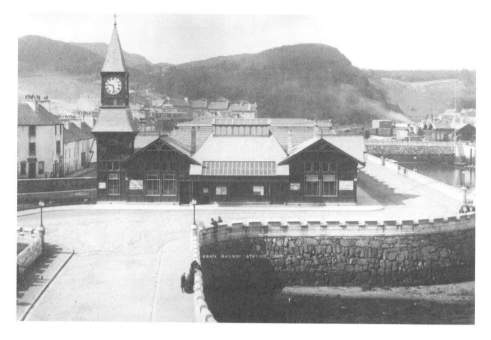

Oban station had a very fine frontage. This view is pre-1903 as the 'suburban platforms' have not been built outside the trainshed to the right. These platforms opened about the same time as the Ballachulish branch and must have been planned with that branch and the ever increasing excursion traffic in mind. The building on the far right of the pier is for the goods station. It bore resemblance to some of the passenger stations on the 'extension'of the line to Oban. (Caledonian Railway Association Collection)

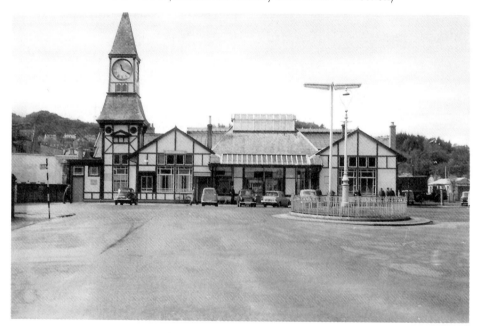

The frontage of Oban station remained little altered in 1963 and even until the end. The new station building was built beside this building to the right. (Doug Carmichael)

Oban viewed from below the McCaig Tower (perhaps more commonly known as 'McCaig's Folly'). The Oban Distillery chimney is in the foreground. This view looks south to the station, seen not long after extension. The pier has been greatly extended too and a large area of it is empty, awaiting use. (Judges Ltd)

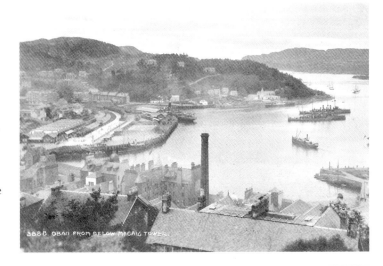

Looking over Oban station in July 1983. The trainshed is trackless but oil traffic is prominent in the sidings. The signal box still stands but all signalling has been removed. (Colin Miller)

A tour train stands in Oban station at night in 1992. The train was rather too long for the platform and ran from the buffers up round the bend up to where the signal box had been located. Oil traffic has faded away. This view is from McCaig's Tower. (Ewan Crawford)

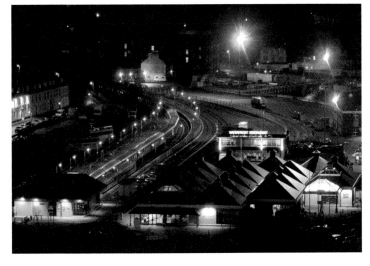

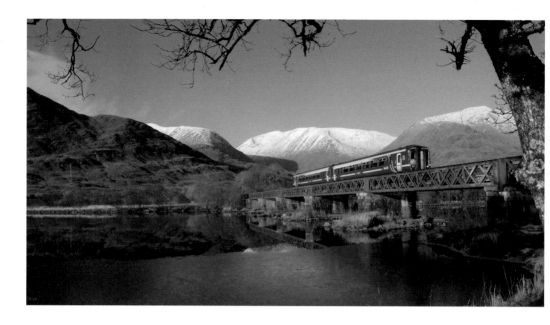

On 11 December 2012, the lunchtime departure from Oban crosses the Orchy Viaduct between Loch Awe and Dalmally stations. (Ewan Crawford)

Acknowledgements

With thanks to:
Louis Archard, Hamish Baillie, Mark Bartlett, Doug Carmichael, John Champney, Beth Crawford, John Furnevel, John Gray, Kenneth Gray, Bruce McCartney, John McGregor, Jim MacIntosh, John McIntyre, Colin Miller, David Panton, Donald Peddie, John Paton, Stuart Rankin, Alasdair Renfrew, G. W. Robin, John Robin, Bill Roberton, David Spaven, John Steven, Jeffray Wotherspoon and John Yellowlees.

Links
- RailScot - my own site, with histories and photographs of Scottish Railways (www.railscot.co.uk)
- Friends of the West Highland Lines - dedicated to improving train services in the West Highlands; membership will help support that effort (www.westhighlandline.org.uk)
- Caledonian Railway Association - studies all aspects of the Caledonian Railway; has a journal and other benefits for members (www.crassoc.org.uk)
- Scottish Railway Preservation Society - has the largest collection of railway locomotives, carriages, wagons, equipment, artefacts and documents outside the NRM(www.srps.org.uk)
- Callander and Oban Railway Signalling Archive - this website has a detailed description of the signalling of the line based on primary sources from opening to the present day(www.oban-line.info)
- ScotRail -the operator of the trains on the West Highland Lines; book your ticket to Oban here (www.scotrail.co.uk)

Further reading (a very small selection)
The Callander and Oban Railway, John Thomas ISBN 0-946537-61-5
The Callander and Oban Railway, C. E. J. Fryer ISBN 0-85361-377-X
Trossachs and West Highlands; Exploring the lost railways, Alasdair Wham ISBN 978-1-872350-34-9
West Highland Railway Through Time, John McGregor ISBN 978-1-4456-1336-9